In Bloom

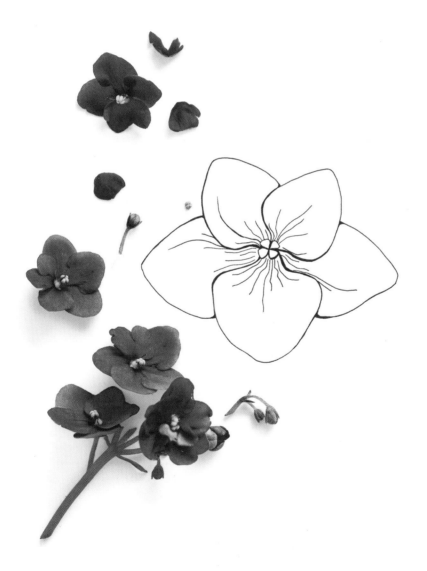

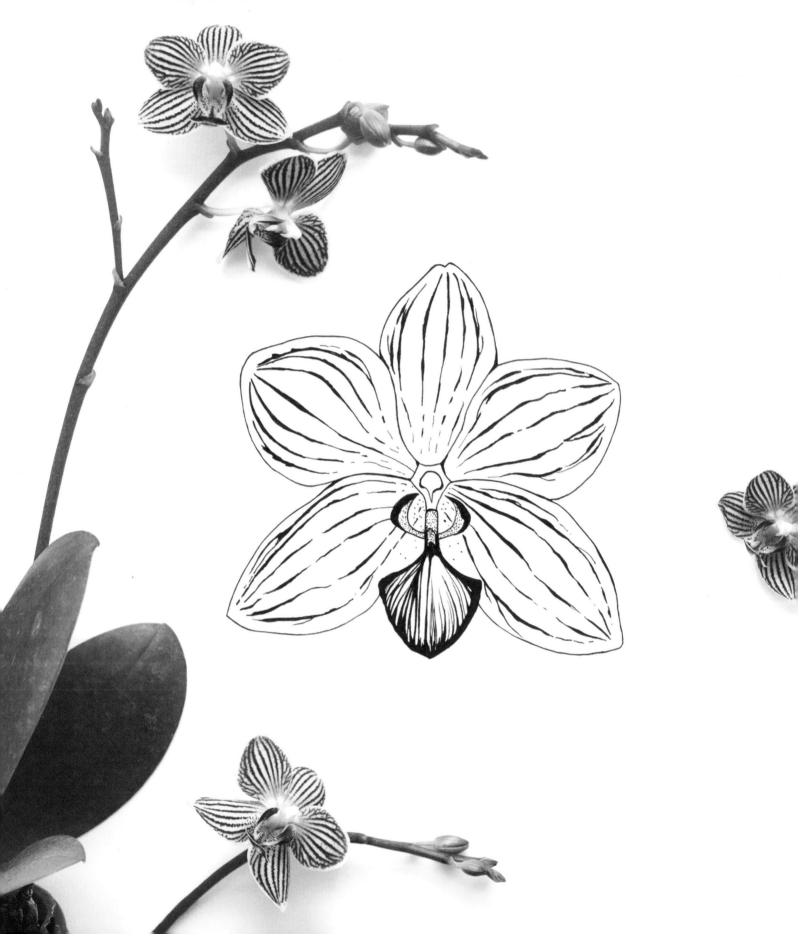

In Bloom

A Step-by-Step Guide to Drawing Lush Florals

RACHEL REINERT

Get Creative 6

Get Creative 6

An Imprint of Mixed Media Resources
104 West 27th Street
New York, NY 10001

Managing Editor
LAURA COOKE

Editor
LAURA COOKE

Art Director
IRENE LEDWITH

Designers
DEBORAH GRISORIO
JENNIFER MARKSON

Editorial Assistant
JACOB SEIFERT

Production
J. ARTHUR MEDIA

Vice President
TRISHA MALCOLM

Chief Operating Officer
CAROLINE KILMER

Production Manager
DAVID JOINNIDES

President
ART JOINNIDES

Chairman
JAY STEIN

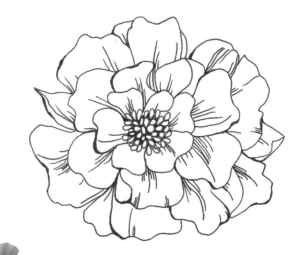

Dedicated to my husband and best friend, Andrew. You've ceaselessly encouraged me in my creativity and never fail to revive my creative spirit.

Library of Congress Cataloging-in-Publication Data
Names: Reinert, Rachel, author.
Title: In bloom : a step-by-step guide to drawing lush florals / by Rachel Reinert.
Description: First edition. | New York : Get Creative 6, [2018]
Identifiers: LCCN 2018007176 | ISBN 9781640210202 (pbk.)
Subjects: LCSH: Drawing--Technique. | Flowers in art. | Drawing from photographs.
Classification: LCC NC730 .R45 2018 | DDC 741.2--dc23
LC record available at https://lccn.loc.gov/2018007176

Manufactured in China

3 5 7 9 10 8 6 4 2

First Edition

Contents

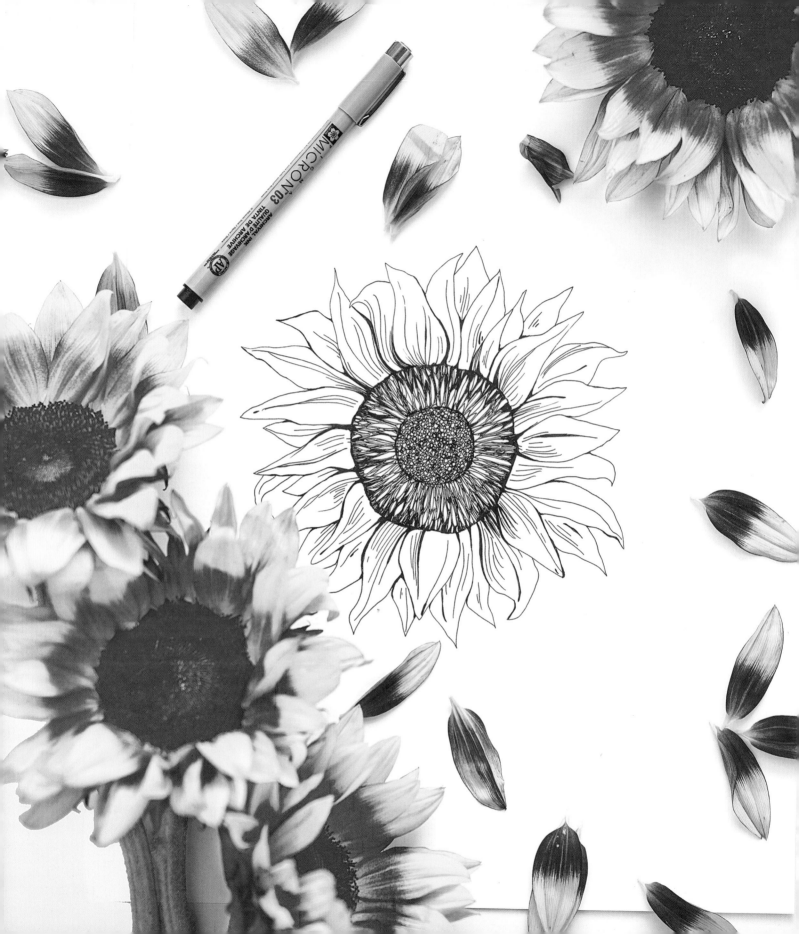

Introduction

FRESHLY CUT FLORALS—SO BEAUTIFUL, YET so fleeting. One way to forever immortalize the ephemeral beauty of flowers is by taking pictures, or by drawing them to capture their essence. Drawing a flower is very different from snapping a photo; it causes us to look closely and spend time in the details of every vein and color change on a petal, to notice its texture and understand its unique form. Upon this close study, it's hard not to foster a deeper respect for flowers as you consider their delicate nature. Taking the time to observe in this way goes beyond wonder. It calms the mind and encourages thoughtful focus. Ready to stop and smell the roses—and the marigolds, hibiscus, lilies, violets, and so much more?

Through my own travels, I've been lucky enough to experience flora from foreign soil, growing freely in its native environment. From the wild Mexican echeveria to the colorful bird of paradise in my own backyard, to the woody banksia trees in Australia and the unique crown of thorns in Cambodia, I've included plants to draw from all around the world. I've also included interesting tidbits of information on each flower, separating them into groups based on their meaning or special traits.

In this book, you'll find step-by-step lessons on how to draw individual flowers and bouquets. I'll even show you how to color them in. In the how-to-draw section, I've greyed out the lines of the previous steps. For each new step, the lines are in black, so you can see clearly what to draw next. Inevitably, some flowers are more simple to draw, and some require more steps and precision. Whether you're a beginner or an adept artist,

you'll find something new to learn and practice. For those that enjoy more of a challenge, you'll find arrangements and bouquets broken down into steps. Hopefully you'll be inspired to create your own drawings of fresh florals.

The fun thing about drawing from nature is that it is really hard to mess up—flowers and plants have so much variation, and each bloom and leaf is truly unique. That leaves a lot of room for freedom to express what you see in your own way, which means you get to have fun with it! You'll see in my drawings that I like to add detail lines in my own style, so use this book as a loose guide and a way for you to practice your own style. I'm just here to root for you and share with you the tools I use to create lovely florals.

I invite you to use this book as a tool to enhance your drawing skills and to nurture a love of nature and florals. May it inspire a joy in your heart for drawing and open doors to new creativity in your life.

—Rachel

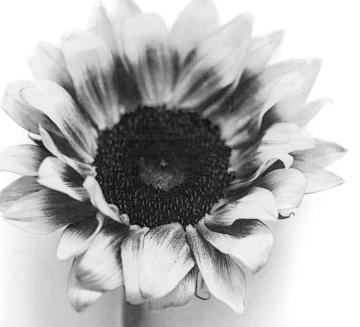

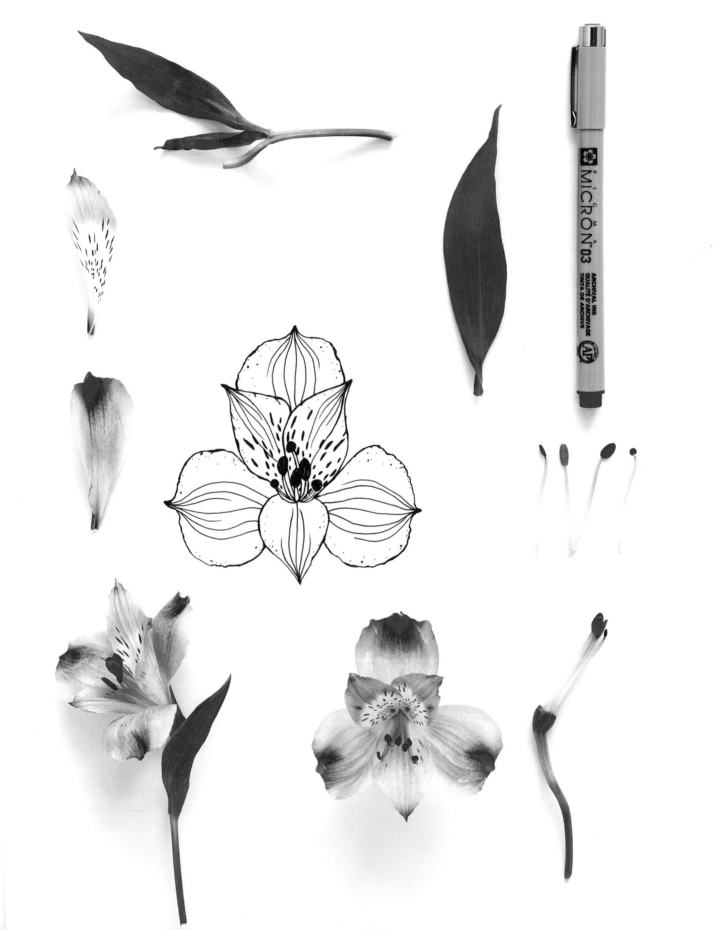

Getting Started

THE BEST WAY TO GET STARTED AT DRAWING anything is to find a reference. Just head outside, and I'm sure you'll be able to find a flower or plant nearby to draw. Nature is all around, even in the city. You just have to look. Maybe pick up a maple leaf, a dandelion, or a bloom from a bush. What's your local flora like? Perhaps your neighbor has an overabundance of hibiscus flowers and she's willing to give you a bloom. You can also head out to a nearby florist to get a freshly cut flower as well as more unique findings.

The Importance of Observational Drawing

I encourage all artists to draw from life. Not only because seeing the real thing up close instills amazement, but because your drawings will be much better. The other reason is that what you draw will be uniquely your work—and this will prevent you from accidentally (or intentionally) plagiarizing art from others. This is important if you want to sell your work or post it as your own. Of course, copying from master artists is very helpful, and I encourage it as a learning tool. But remember that you must credit the original artist if you post it, and you can't sell it.

Taking your own photos of flowers can also work as a great reference, though it flattens objects, making it harder to perceive changes in shadow and form. This is actually a great thing for beginners, especially when it comes to line drawing. Head to a botanical garden or set out on a hike with your camera. But keep in mind that if you want to color the bloom in the future, a real reference is the best.

Warming Up

Before you begin, I suggest warming up. Grab some scratch paper, find your reference, and loosen your grip on your pencil. Draw medium-sized circles over and over, until your wrist has learned the motion and your precision has improved. Practice other basic shapes and give yourself the freedom to be messy. Play with various line weights and pressures, making tapered edges, curls and curves, harsh straight lines, wobbly lines, dots, or jagged edges.

We will be drawing a lot of organic shapes for the flowers in this book, and I will refer to them as heart shapes, stars, diamonds, clouds, triangles, ovals, circles, or teardrops. Oftentimes I will use a pencil to sketch loose guides with basic shapes before I draw anything detailed. This is good practice for all artists, and I encourage the same for you.

Tools

The great thing about drawing is that it just requires a simple pen and paper. While I'm a big fan of being resourceful and creating with what I already have, there are just some materials that are better than others. For best results, I would use archival drawing pens and paper to make your mark the best that it can be. I use Sakura Pigma Micron black ink pens, sizes 02-04. I prefer size 03 for most of my main line work, and use size 02 for detail lines.

Occasionally I use a size 04 for thicker lines or for coloring areas in. For paper, I recommend using Strathmore Bristol paper, smooth surface, 100 lbs. It's thick and smooth, perfect for erasing lots of sketched lines and inking beautifully. I also use a pencil and eraser for sketching all flowers before I am ready to ink them. My favorite is the Rotring mechanical pencil and a Pentel high-polymer white eraser.

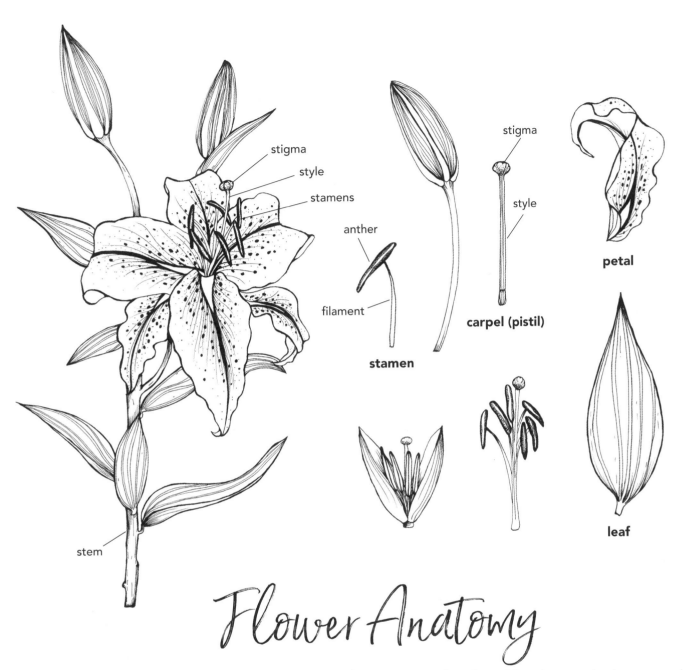

stigma

style

stamens

anther

filament

stamen

stigma

style

carpel (pistil)

petal

leaf

stem

Flower Anatomy

KNOWING THE ANATOMY OF A FLOWER HELPS us to understand what it is we're drawing and gives us names to its parts. The flower on a given plant is its reproductive part, producing pollen to attract bees so that it can reproduce seeds. Some flowers have male and female reproductive organs, and some flowers have just male or just female.

We'll use the stargazer lily as an example, since it's easy to see its distinctive parts. The stargazer lily has both male and female reproductive organs. In the center of the flower is the female reproductive organ, or the *carpel*, also called a *pistil* for each individual body. The long tube is called a *style*, and the top rounded disk that receives pollen is called the *stigma*. The male parts are called the stamens. They are made up of *anthers* and *filaments*. The anther produces pollen and is held up by the filament.

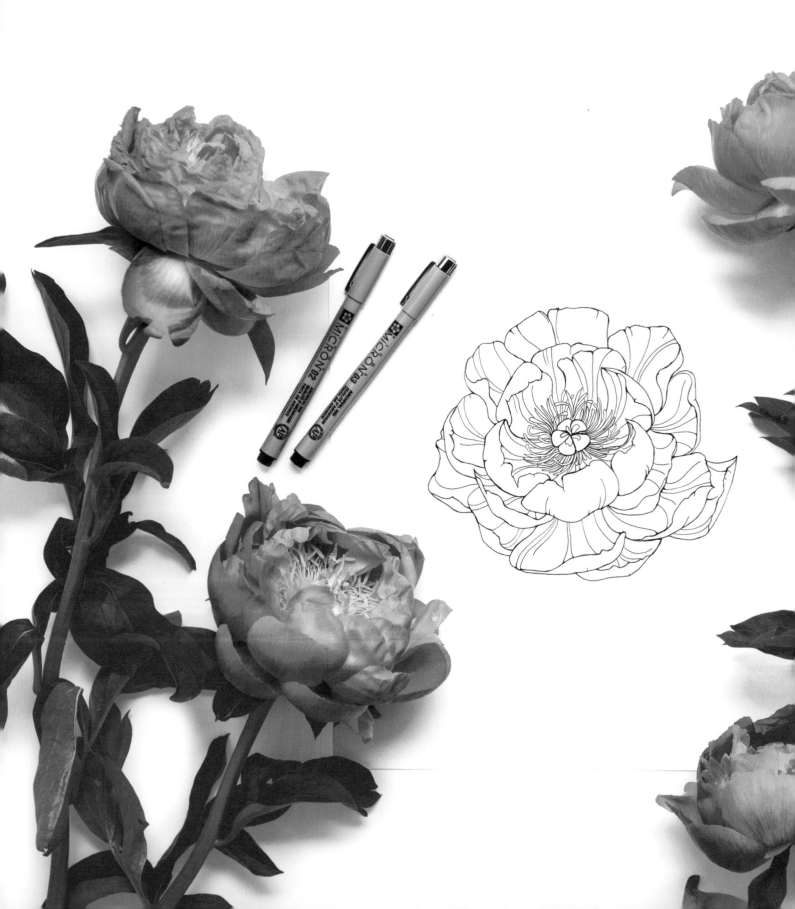

Flora of the Americas

Alstroemeria

Echeveria

Bromeliad

Sunflower

Poinsettia

Peony

Dahlia

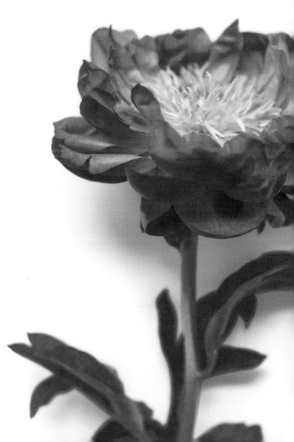

Alstroemeria

Alstroemeria aurantiaca
Romantic
NATIVE TO SOUTH AMERICA

Also known as the Peruvian lily, the alstroemeria is a symbol of devotion and was originally found growing in Peru, Chile, and Brazil. These long-lasting blooms are flirty and romantic, and they come in many colors.

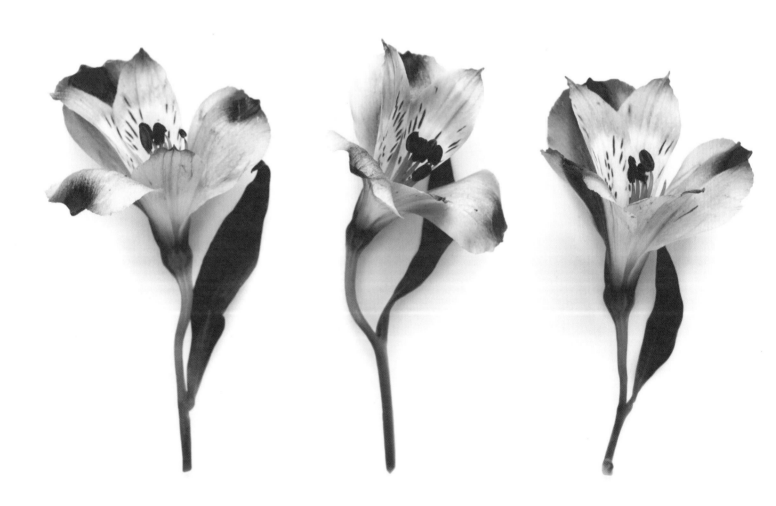

1 Begin by drawing the stamens. Draw three filaments with large oval anthers and three filaments with smaller oval anthers, all coming from one point.

2 Draw three teardrop-shaped petals behind the stamens. Make one petal point downward, facing straight on. The other two will face upward, with one overlapping the other.

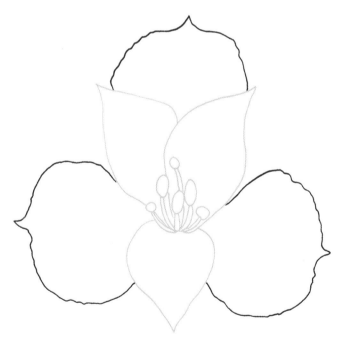

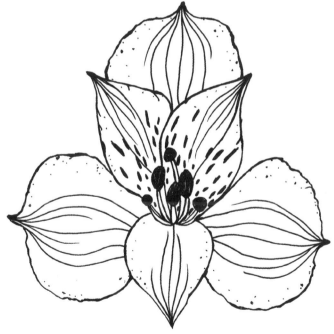

3 Draw three larger petals with wider ends that come to a tiny point. Balance them out evenly, with one behind the smaller top two petals and one on either side of the smaller bottom petal. These larger petals can have slightly jagged ends.

4 Now add in the detail lines. From each petal tip, draw lines down to the base as shown, with the outer lines curving along the shape of the petal. Fill the anthers in with black. Add small, solid black ovals to the two inner petals starting from the base, stopping before you reach the tip. You can add little dots around the petals as well for added interest.

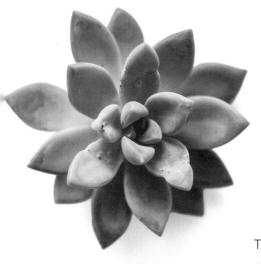

Echeveria

Echeveria
Enduring
NATIVE TO MEXICO AND CENTRAL AMERICA

There are more than 100 species of echeveria, a flowering succulent native to Central America and Mexico. Beyond the dazzling variety of colors, sizes, and beautiful rosettes, succulents are truly magical. New baby plants can grow from a fallen leaf. Because they store water in their leaves, they are drought tolerant. And, as most of them grow in Mexico, they can withstand exceedingly hot temperatures, painting the desert in shades of pink, blue, green, and purple.

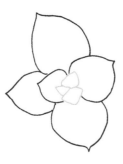

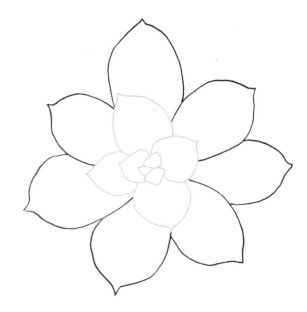

1 Begin by loosely drawing three tiny, triangular shapes in a clump.

2 From the outer edges of the triangular shapes, draw plump, tear-shaped leaves as shown. Begin to overlap them evenly, creating a rosette.

3 Circling around the rosette, fill in more leaves behind the last layer in the same way, making them a little longer and larger.

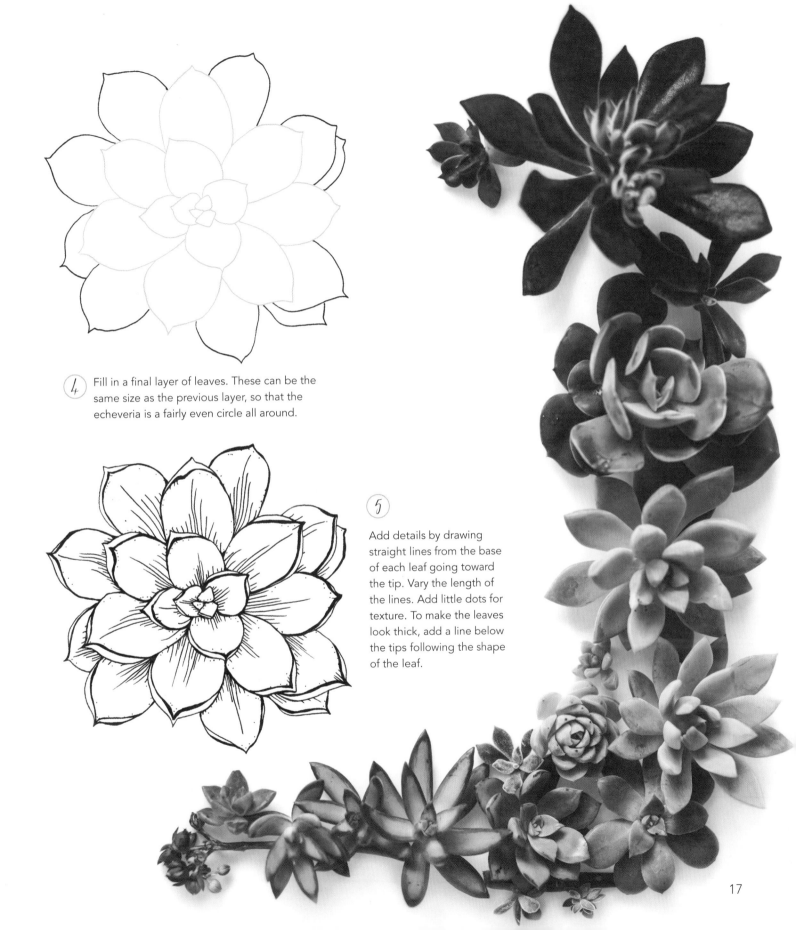

4. Fill in a final layer of leaves. These can be the same size as the previous layer, so that the echeveria is a fairly even circle all around.

5. Add details by drawing straight lines from the base of each leaf going toward the tip. Vary the length of the lines. Add little dots for texture. To make the leaves look thick, add a line below the tips following the shape of the leaf.

17

Bromeliad

Bromeliaceae
Exotic
NATIVE TO LATIN AMERICA AND THE CARIBBEAN

Native to Latin America and the Caribbean, the bromeliad is a tropical plant featuring brilliant, brightly colored flower stalks. It shares the same family as the pineapple. The shape of the leaves leads rainwater to pool in the bromeliad's center, creating ecosystems for frogs and other animals to live in. They are diverse, with many different shapes, sizes, and colors.

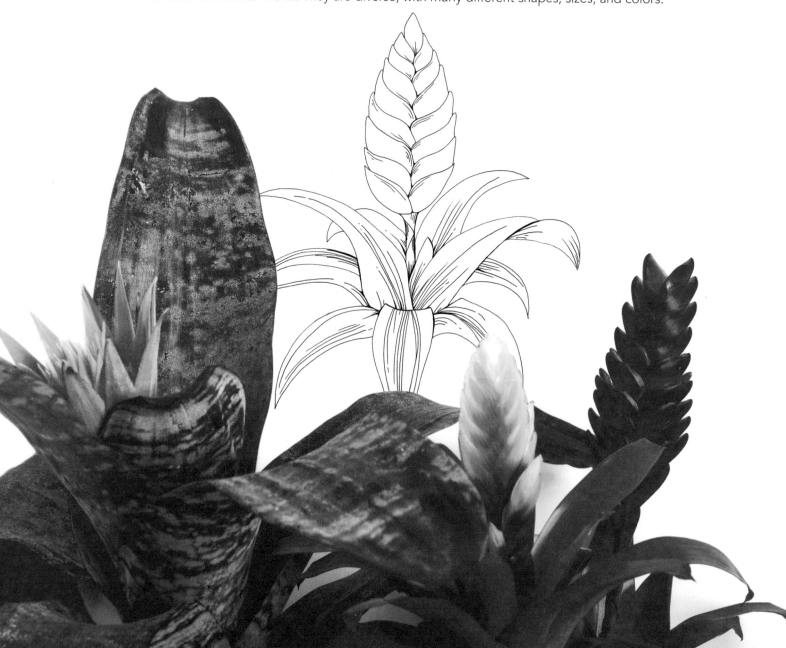

1 Lightly sketch a large vertical oval with your pencil, with the top coming to a soft point.

2 Using the oval as a loose guide, begin drawing the flower sections. Start at the bottom and draw an elongated teardrop shape facing slightly to the left, with the tip coming to the edge of the oval. Next, draw the same shape mirrored on the right side, and tuck it slightly behind the shape on the left. Repeat these shapes moving upward, with each new set of shapes tucking in to the pair below it.

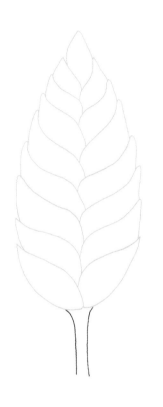

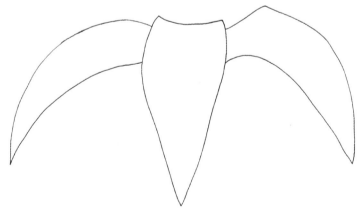

3 Finish the flower stalk by continuing with the mirrored teardrop pattern all the way to the top of the original oval, drawing each pair of shapes a little smaller the higher you go. The highest shape will be positioned straight up and down. Erase the large oval that was used as a guide.

4 Draw two lines coming down from the flower stalk to create a short stem. Next, draw a leaf facing you, making the top flat and bringing the edges into a long triangle. Leave a little bit of space between the leaf and stem. On either side of that leaf, draw two more leaves coming from its sides, curving downward.

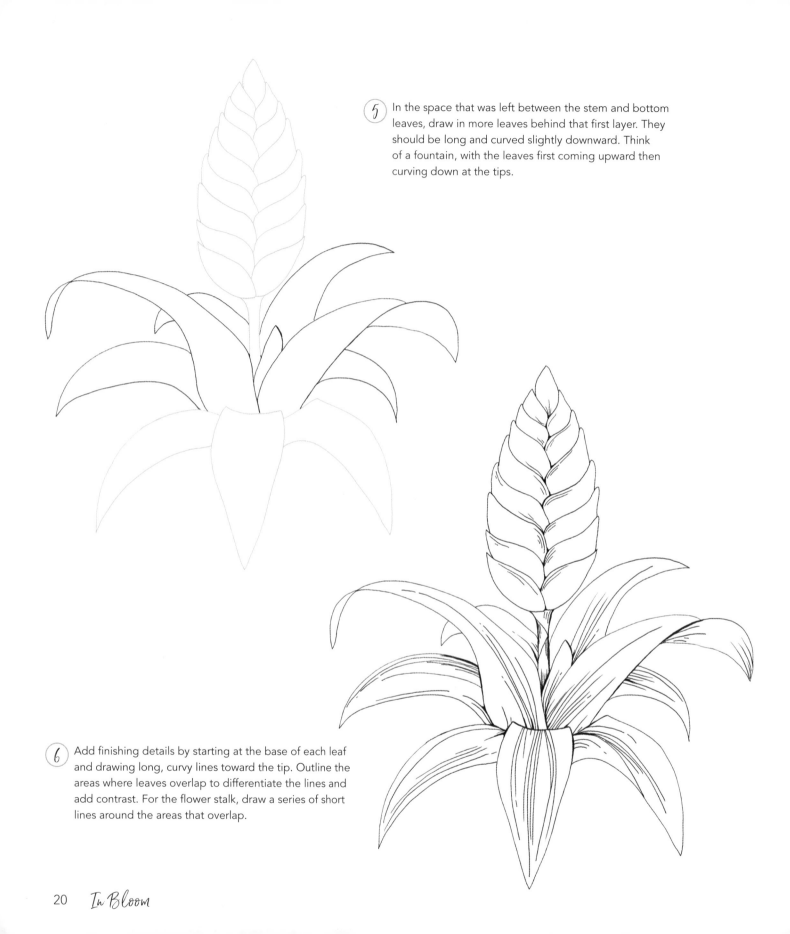

5 In the space that was left between the stem and bottom
 leaves, draw in more leaves behind that first layer. They
 should be long and curved slightly downward. Think
 of a fountain, with the leaves first coming upward then
 curving down at the tips.

6 Add finishing details by starting at the base of each leaf
 and drawing long, curvy lines toward the tip. Outline the
 areas where leaves overlap to differentiate the lines and
 add contrast. For the flower stalk, draw a series of short
 lines around the areas that overlap.

Sunflower

Helianthus annuus
Wild
NATIVE TO NORTH AMERICA

Embodying the warmth of the American summer, the sensational sunflower undoubtedly imbues happiness and joy with its massive, bright yellow petals. Native to North America, this wild flower is known for being hardy and able to survive in extreme heat, thriving in all 50 U.S. states. Sunflowers were cultivated by Native Americans as far back as 3000 BC for food and medicine. They can reach up to three meters high, and each sunflower head is made up of thousands of tiny flowers.

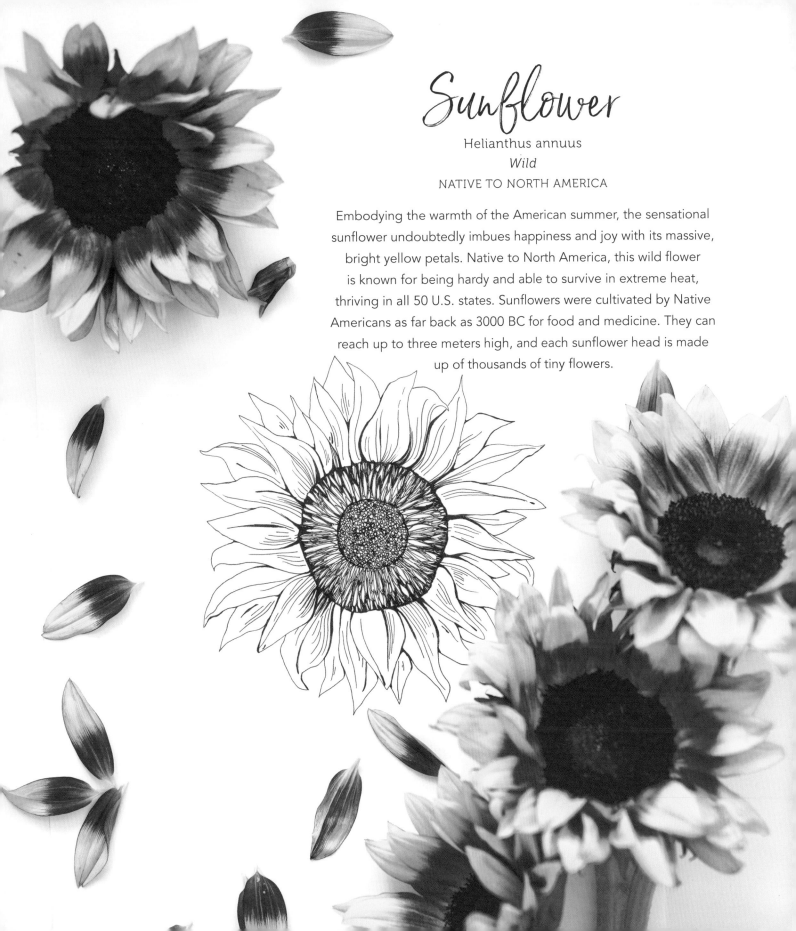

(1) Loosely draw two large circles, one within the other, like a cracked egg.

(2) Completely fill in the inner circle with many tiny circles. They don't have to be perfect. Fill in any white gaps with black.

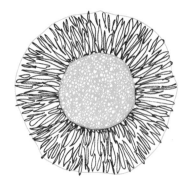

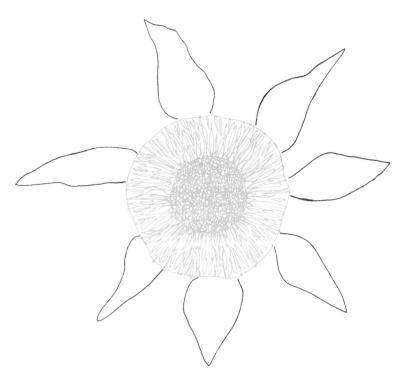

(3) Next, draw in the *disc florets*, or many tiny flowers going around the center. These are shaped like ovals tapered on each side. Start from the edge of the center circle and work outward.

(4) Now begin to draw the petals around the sunflower head. Start off with six or seven, spaced evenly around the head. They look like stretched-out teardrop shapes, with some of them curving in different directions.

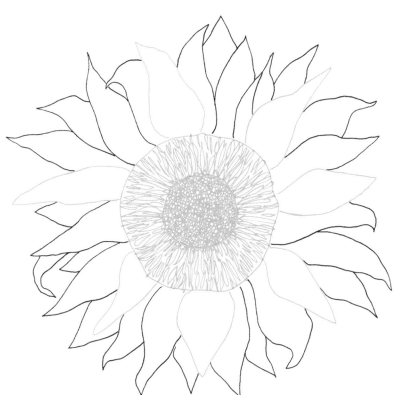

Tip

Sketch a large circle to act as a guide in order to keep the petals the same length when drawing them.

5) Draw the rest of the petals as in the previous step, going around the head of the flower in a circle. They should all be around the same length, with about three layers overlapping slightly. Vary a few here and there with thinner tips or curved edges for variety.

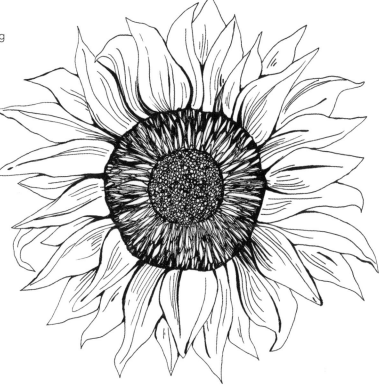

6) Finish the flower by filling in any white spaces between the disc florets with black, and outline the petals to make them stand out. Draw several long, spaced-out lines of varying lengths within each petal.

Poinsettia

Euphorbia pulcherrima
Festive
NATIVE TO MEXICO

Indigenous to Mexico, the poinsettia is an iconic Christmas plant used as a festive decoration because of its red and green foliage. Starting in the 17th century, Franciscan friars began using them as decorations during Christmas in Mexico. It is said that the poinsettia's star-shaped leaves mimic the star of Bethlehem. It is called the *Flor de Noche Buena* (or Christmas Eve Flower) in Mexico and Guatemala.

Tip

The poinsettia leaves can be broken down into layers of star shapes, so feel free to sketch guiding lines shaped like stars.

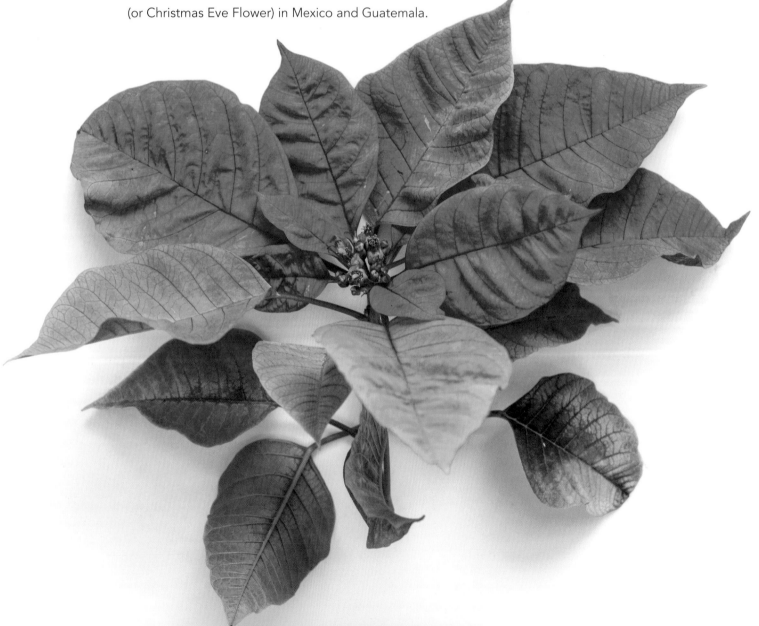

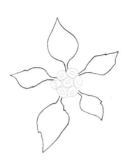

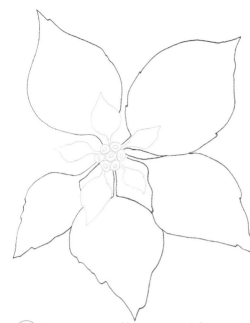

① Begin by drawing a small circle with another small oval inside of it. Then draw six more similar "eyeball" shapes clustered around the center one.

② Draw the first set of leaves, creating a small star shape. The leaves come from the center of the flower, become rounded, and end with a pointed tip. Draw five of these for the first layer, with some having jagged edges.

③ The next layer of leaves is much bigger. It is still in a star shape with five leaves, though one of the leaves can be smaller for variety. This layer of leaves is overlapped by the first, and the leaves don't have to be perfectly spaced.

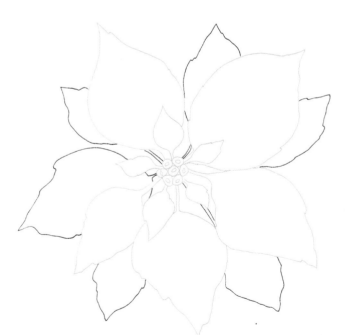

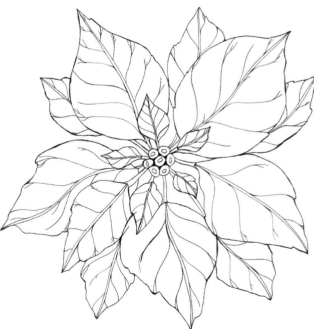

④ Repeat the last step, drawing another layer of leaves behind the last. This time you can draw six leaves if there are gaps that need to be filled.

⑤ Draw the detail lines of the leaves by adding in veins. In the center of each leaf, draw two long, thin lines from the tip to the base to create the stem. From the stem, draw softly curving lines out to the edges of the leaf.

Peony

Paeonia
Enchanting
NATIVE TO NORTH AMERICA, EUROPE, AND ASIA

If you've ever held a peony up close, you've experienced its magical beauty. With its lush, rounded petals, the peony can unfurl into an enchanting 10-inch flower. A blooming bouquet is quite a spectacle. It's no wonder these incredible flowers are coveted for bridal bouquets. Some species can still be found growing wild in areas of Western North America, Europe, and Asia.

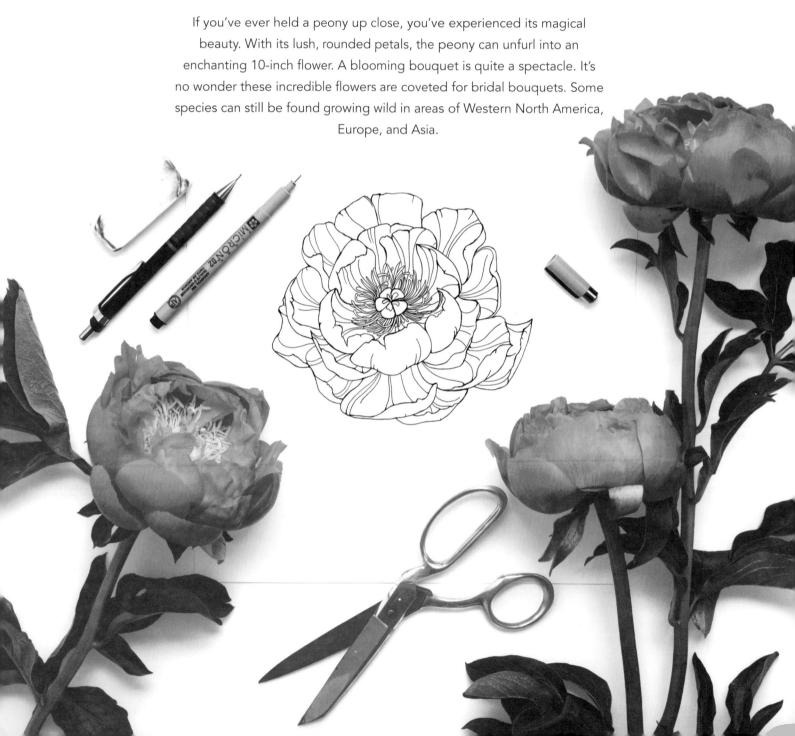

1. Begin by drawing the innermost part of the flower, or the pistil. Draw five candy-corn shapes in a circle, with the tips touching. Draw smaller, wavy shapes at the narrow tip of each candy corn.

2. From the edges of the pistil, draw the long and curving stamens coming outward in all directions. The anthers should be rounded.

3. Continue adding in more stamens, overlapping one over another and filling in the spaces to create a ring around the pistil.

4. Now begin to draw petals around the base of the flower. Start with the petal closest to you, drawing a loose oval shape with a jagged edge at the top. Then draw petals on either side of that one, overlapping them slightly. These inner petals are curved inward. Cup your hands and imagine the petals are like that shape. Notice how you can see the inside, top, and outside of your hand because it is three-dimensional. The edges of the petals are slightly ruffled, so draw jagged lines at the top of each petal.

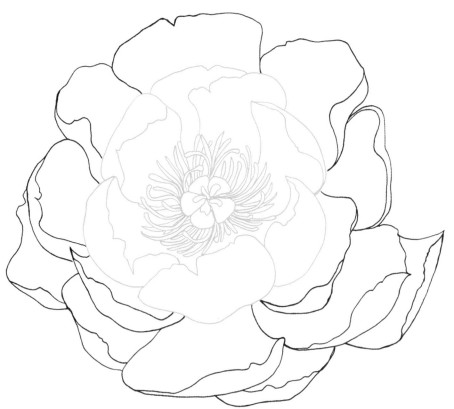

Draw the outer petals in that same way, going around the base of the flower in a circle. The outer petals are more opened and will curve less inward than the first layer. Draw two to four overlapping layers of petals, each one slightly behind the previous set. The closest petals will show their insides and part of their outsides, since they are slightly curved upward. Again, use cupped hands as a reference, moving them around as if they are petals to see the change in angles.

After all of the petals have been drawn, finish the flower by adding in the details. Draw long, curving, spaced-out lines from the tips of the inner petals to the base. Outline some of the petals to make them a little darker in order to differentiate the detail lines from the petal shapes.

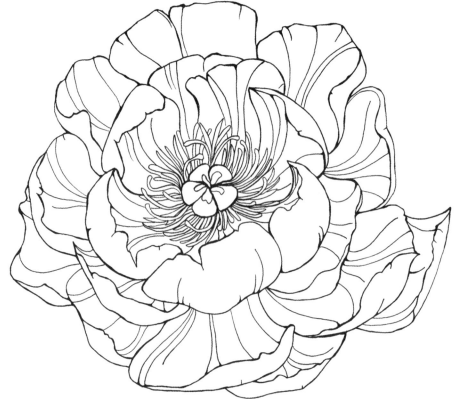

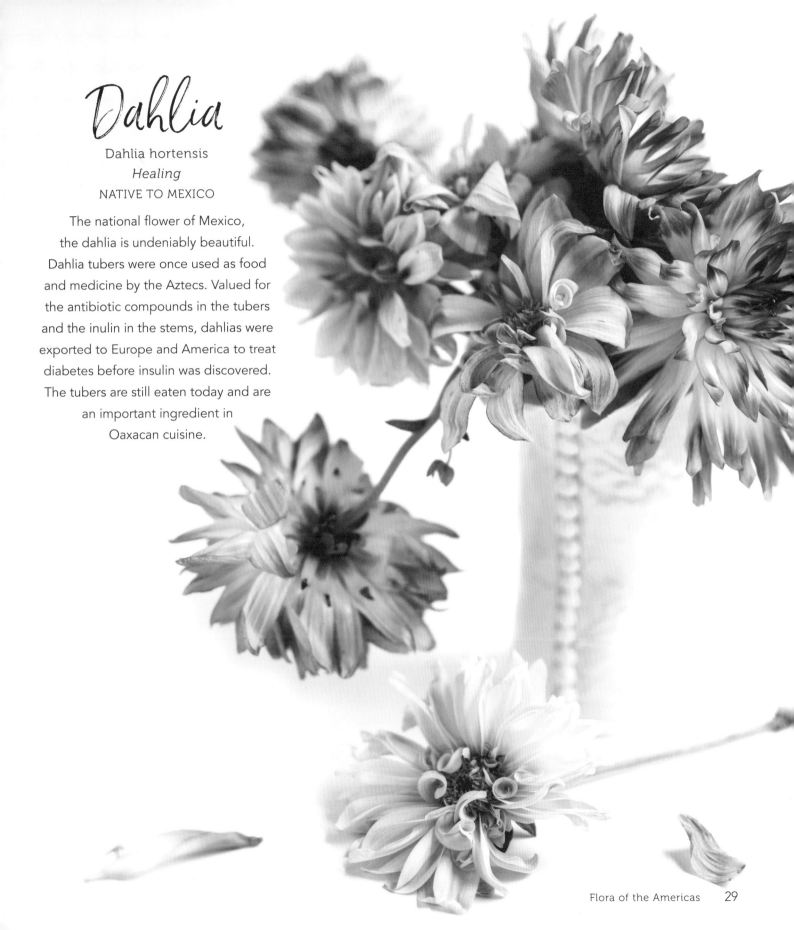

Dahlia

Dahlia hortensis
Healing
NATIVE TO MEXICO

The national flower of Mexico, the dahlia is undeniably beautiful. Dahlia tubers were once used as food and medicine by the Aztecs. Valued for the antibiotic compounds in the tubers and the inulin in the stems, dahlias were exported to Europe and America to treat diabetes before insulin was discovered. The tubers are still eaten today and are an important ingredient in Oaxacan cuisine.

1. Start by drawing a tiny circle for the center of the dahlia. From there, layer and overlap multiple half-circles behind it to create an even circle with this pattern. It should be about the size of a dime.

2. Add many little disc florets around the circle. These should look like curved slivers going in every direction.

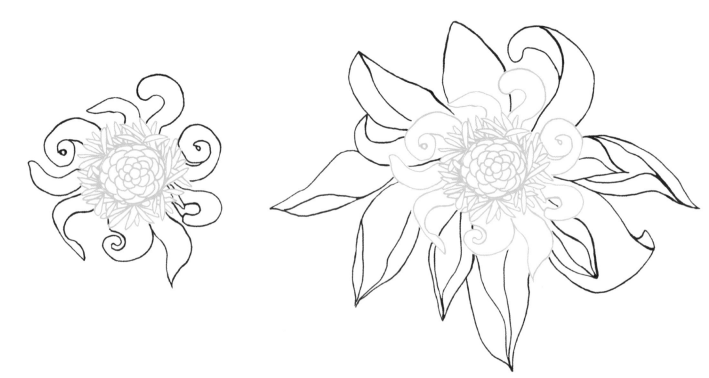

3. The innermost petals of the dahlia are sometimes curled inward. Draw several small petals with tight curls at the tips behind the disc florets and a few small petals with varying curves and twists.

4. Draw the next layer of petals behind those drawn in step three, making them a little bigger. Dahlia petals curve inward like a cone and have pointed tips, so draw one or two lines on each petal, like bunny ears, to create this look.

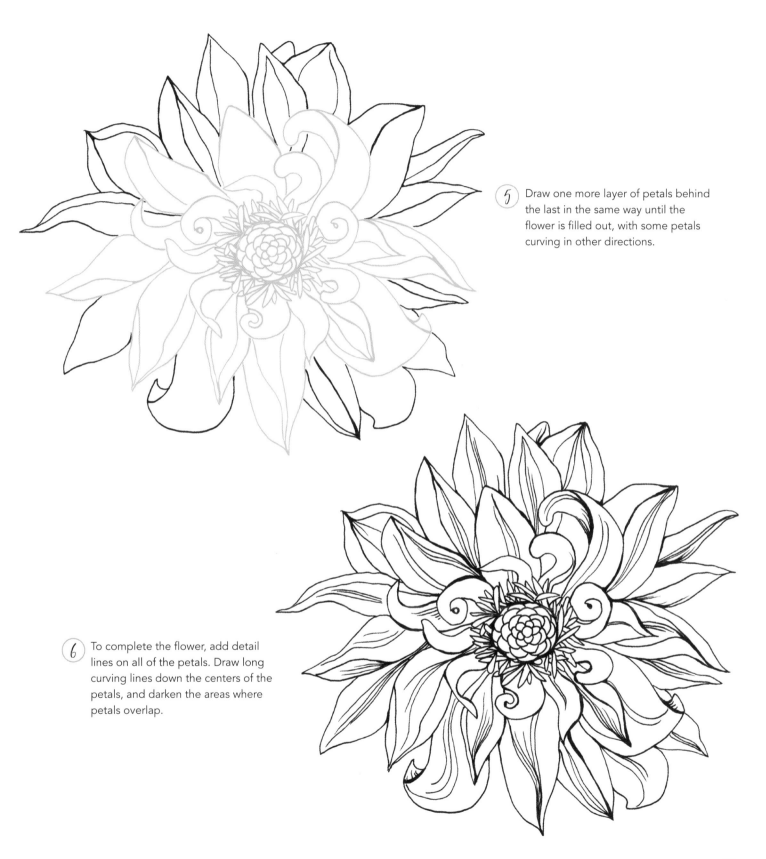

5 Draw one more layer of petals behind
 the last in the same way until the
 flower is filled out, with some petals
 curving in other directions.

6 To complete the flower, add detail
 lines on all of the petals. Draw long
 curving lines down the centers of the
 petals, and darken the areas where
 petals overlap.

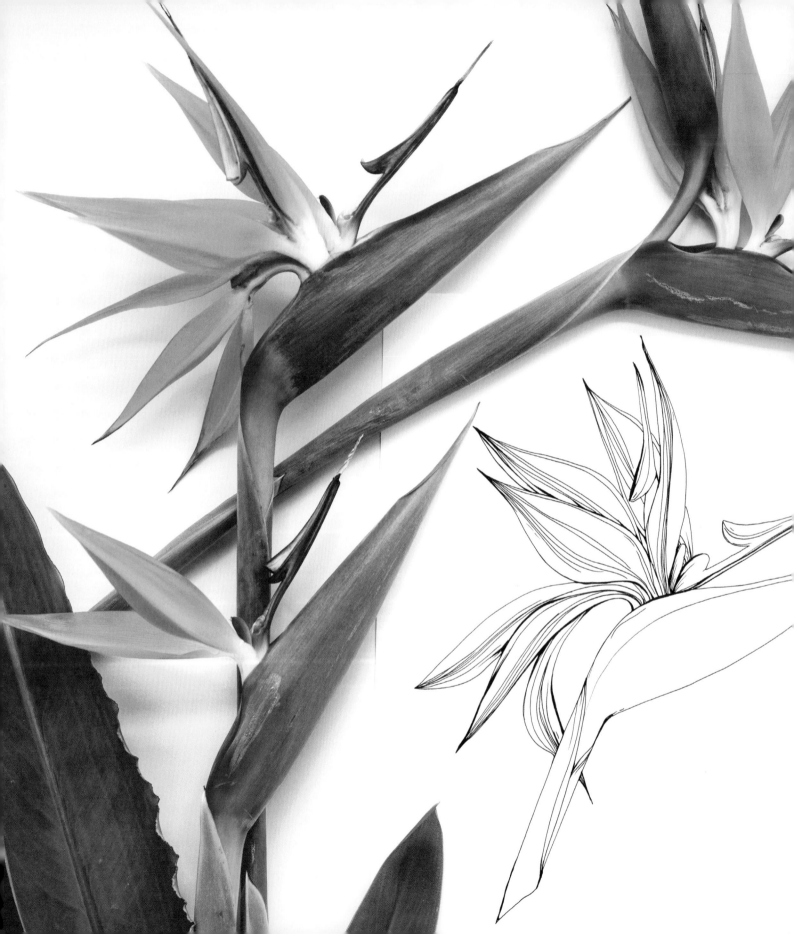

Flourishing Africa

African Violet

Hibiscus

Calla Lily

Bird of Paradise

Aloe

King Protea

Gerbera Daisy

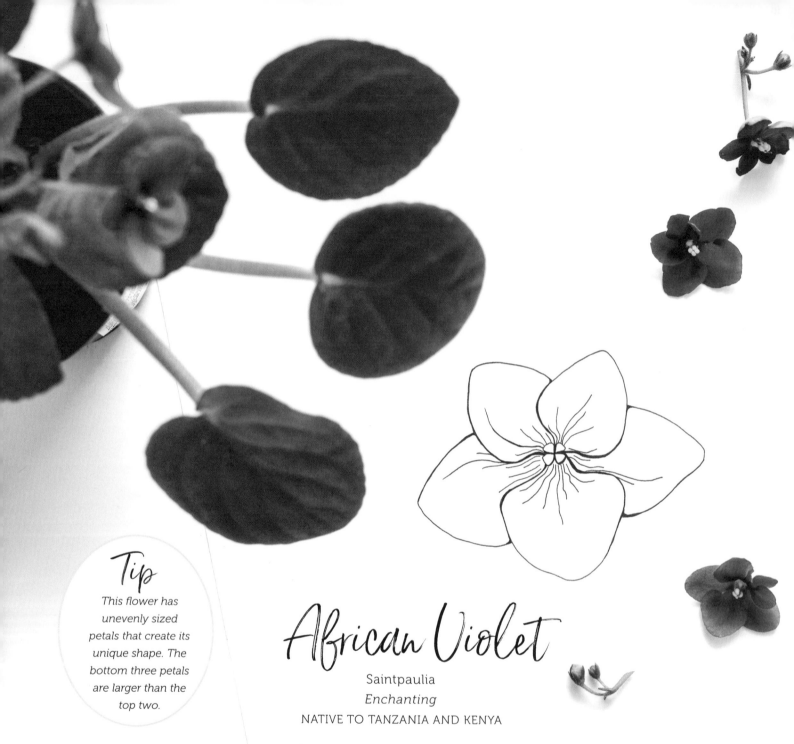

African Violet

Saintpaulia
Enchanting
NATIVE TO TANZANIA AND KENYA

The African violet represents spiritual wisdom and is seen as a protective and spiritual plant. Some believe it holds magical attributes. Native to Tanzania and Kenya, this delicate flower has deep purple, fuzzy petals and grows in the tropical cloud forest habitat. (In Africa, the color purple is worn by nobility and represents prosperity and good luck.) Many species are now threatened due to their native habitats being cleared.

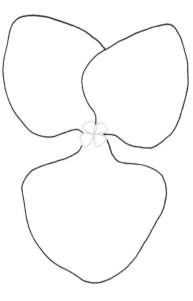

1. Start by drawing the anthers, which look like four small, teardrop shapes coming from one point, similar to a four-leaf clover.

2. Next you will draw three slightly pointed spoon-like petals coming out from the anthers. The bottom petal will be a little larger than the other two and will come straight down from the anthers. The top two will come upward and overlap each other slightly, with their tips facing opposite directions. Leave an even space on each side of the flower for the last petals.

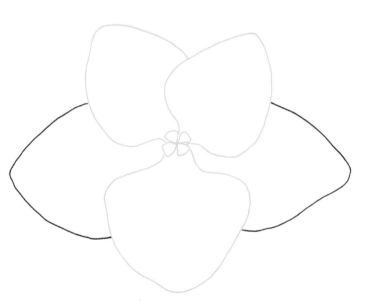

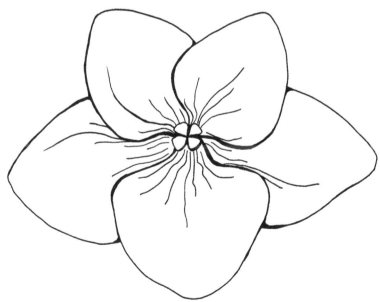

3. To complete the flower, draw two more large spoon-shaped petals, coming out from the flower horizontally behind the first layer of petals. They will mirror each other on either side evenly.

4. Add in the details of the flower by darkening the outer petals and the areas where they overlap. Do this by drawing crinkled, curving lines coming outward from the anthers into the petals.

Hibiscus

Hibiscus rosa-sinensis

Wild

NATIVE TO MADAGASCAR, MAURITIUS, FIJI, PACIFIC ISLANDS, AND ASIA

The beloved hibiscus can be found all over the globe, growing wild in many tropical or mild climates. These sun-loving, vigorous flowers come in many vibrant colors, with impressive carpels and huge petals. The red hibiscus petals are dried and boiled into a tea that is drunk in Egypt, Sudan, West Africa, and Ghana.

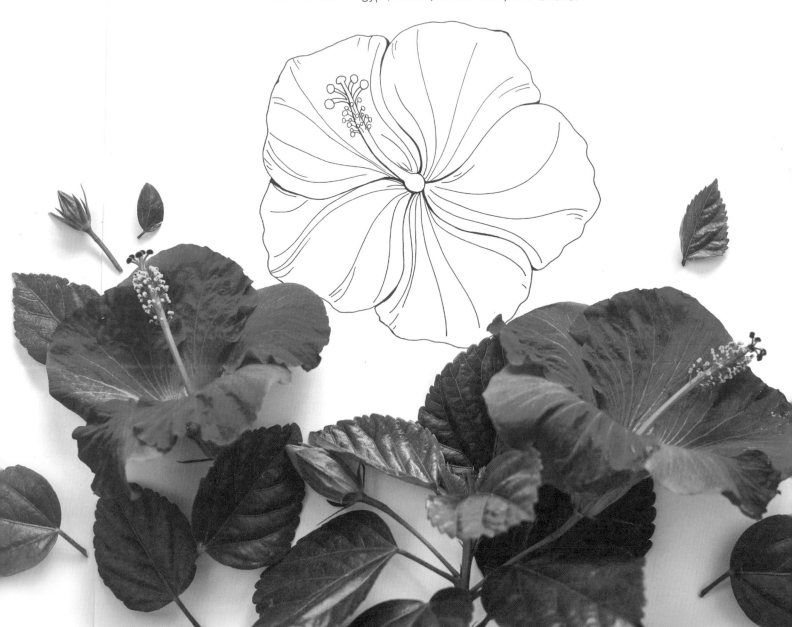

Tip

If some of the terms in this lesson aren't familiar, refer to the flower anatomy diagrams on p. 11.

1. With a pencil, sketch a large circle. In the very middle draw a small circle, but leave an opening for the pistil.

2. Draw the style curving up from the opening in the center circle, coming close to the edge of the large circle but not touching it. Create the stigma by drawing five little branches with circular tops at the upper end of the style.

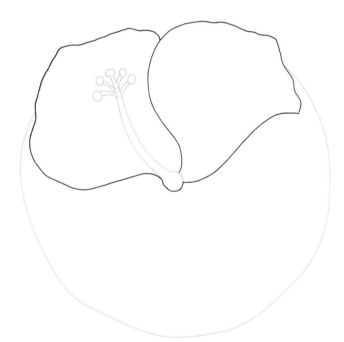

3. Begin to draw the first two petals using the large circle as a guide. You will draw five petals total that are evenly spaced out. Draw an "S" curve where one petal overlaps the other. The petal tips can go a little beyond the circle to end in a soft line with wavy edges.

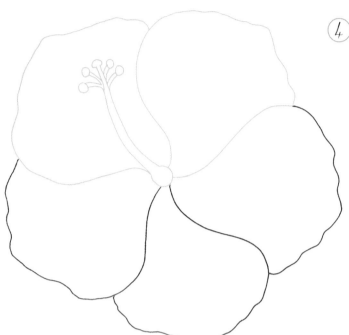

4 Complete the flower by drawing the last three petals in the same way you did for the first two.

5 To finalize the details, thicken the lines where the petals overlap, and add long curving lines in each petal going from the base to the tip. Finally, add in the tiny stamens by drawing little circles for the anthers and single lines for the filaments right below the stigma.

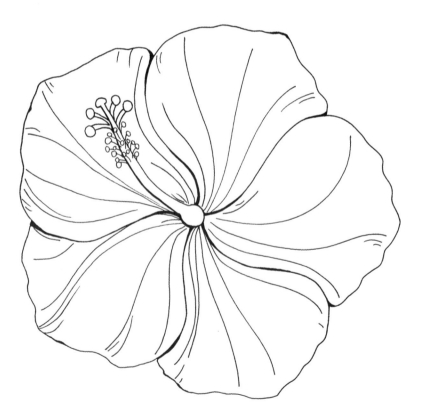

Calla Lily

Zantedeschia aethiopica
Romantic
NATIVE TO SOUTH AFRICA

Calla is a Greek word meaning "beautiful," so it makes sense that the
South African–native calla lily is associated with youth and rebirth. Commonly used in
bridal bouquets to represent purity, the calla lily holds several meanings depending on
its color, with white representing innocence and pink tones with romance. The flower is
unique in that it is shaped like a funnel or trumpet with a prominent pistil.

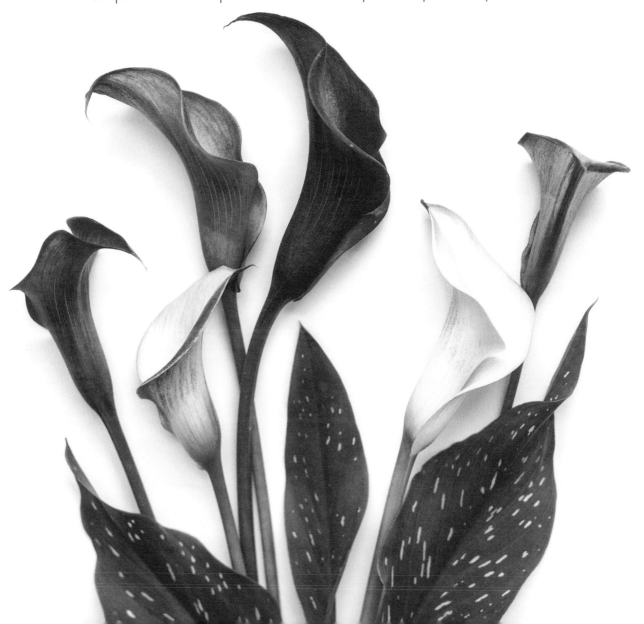

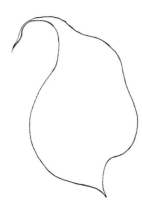

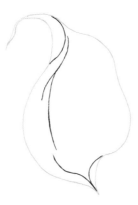

1. Start by drawing the large *spathe*. Draw a large rounded spoon shape that comes to a long, thin, curving end tapered at both the top and bottom. This should be a soft, curving shape.

2. Now we are going to develop the inner part of the spathe a bit more. Inside the shape, separate the tapered top with a soft curving line as shown. Draw a long curving line down the left side of the spathe to reveal the inside of the flower. At the bottom of the spathe where it comes to a point, draw a Y-shape to create folds.

3. Draw the pistil, which is actually the real flower head, in the center of the spathe connected to the left arm of the Y-shape. Then draw the bottom half of the spathe, which comes down into a cone shape. Curl the bottom petals so that they overlap themselves, and connect them to the top of the spathe.

4. Now, create the stem by drawing two long, thin lines connected to the end of the spathe, but leave the bottom unfinished. Draw two more long, skinny lines to the side of the flower leaving them unconnected to the stem. These lines will be the leaf veins.

Tip

The main "petal" we see on the flower is actually called a spathe, which is a trumpet-shaped bract surrounding the pistil.

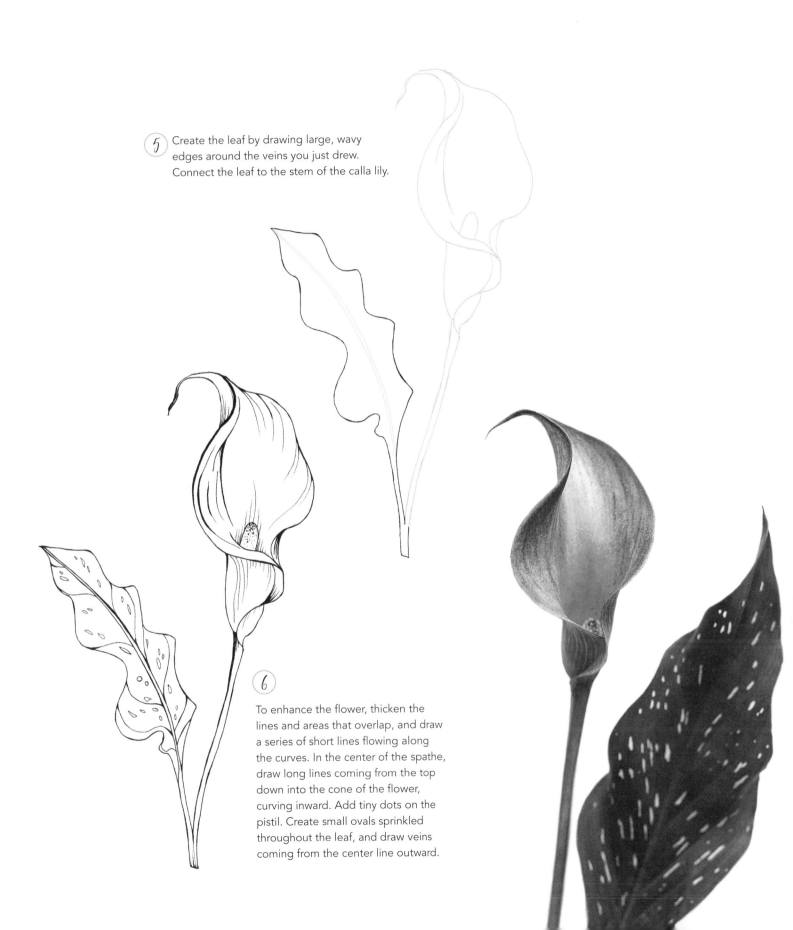

5 Create the leaf by drawing large, wavy edges around the veins you just drew. Connect the leaf to the stem of the calla lily.

6

To enhance the flower, thicken the lines and areas that overlap, and draw a series of short lines flowing along the curves. In the center of the spathe, draw long lines coming from the top down into the cone of the flower, curving inward. Add tiny dots on the pistil. Create small ovals sprinkled throughout the leaf, and draw veins coming from the center line outward.

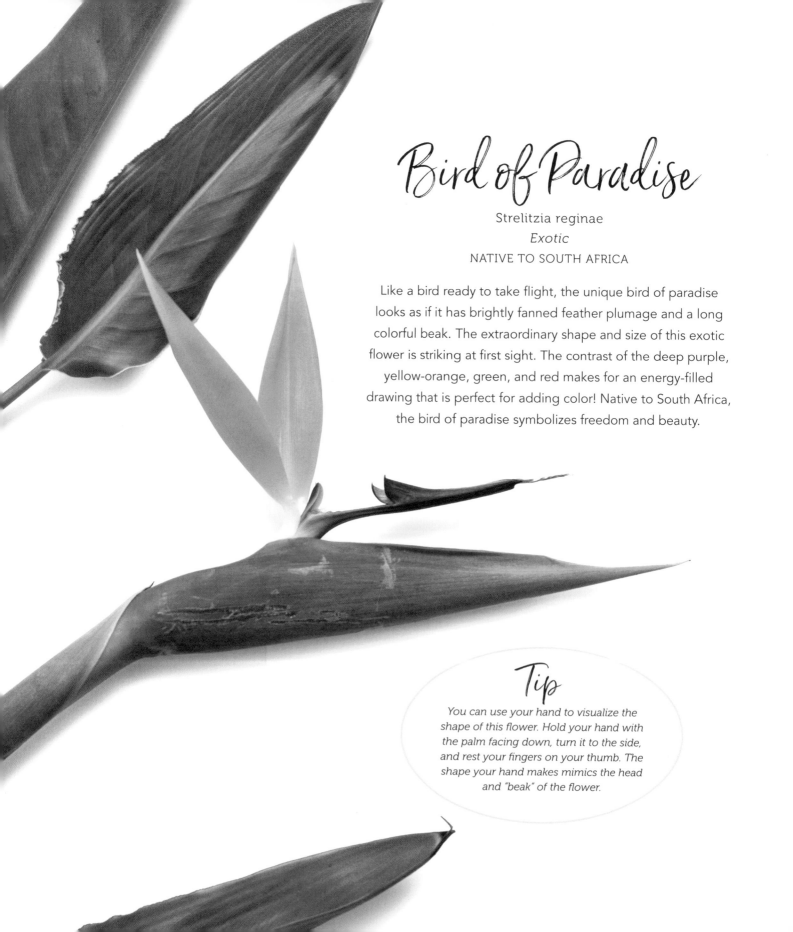

Bird of Paradise

Strelitzia reginae
Exotic
NATIVE TO SOUTH AFRICA

Like a bird ready to take flight, the unique bird of paradise looks as if it has brightly fanned feather plumage and a long colorful beak. The extraordinary shape and size of this exotic flower is striking at first sight. The contrast of the deep purple, yellow-orange, green, and red makes for an energy-filled drawing that is perfect for adding color! Native to South Africa, the bird of paradise symbolizes freedom and beauty.

Tip

You can use your hand to visualize the shape of this flower. Hold your hand with the palm facing down, turn it to the side, and rest your fingers on your thumb. The shape your hand makes mimics the head and "beak" of the flower.

1. Begin by drawing the outline of the flower's boat-shaped head and its neck. The neck should be skinnier than the head. Elongate the beak so that it comes to a point.

2. At the top of the largest part of the head, draw two large petals going upward. Start off thin at the base and then widen the middle, like a teardrop shape. The top of the petals should be pointed and long, almost as long as the length of the head.

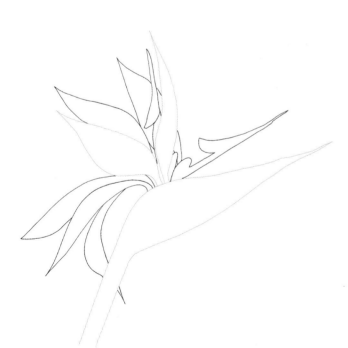

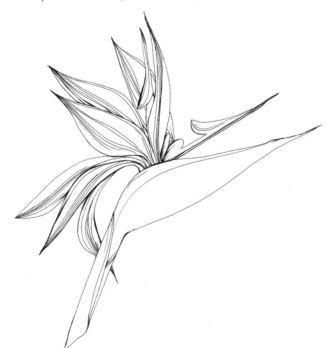

3. Draw a long, pointy, half-arrow shape jutting out toward the "beak." Draw a second one as a layer behind one of the middle petals. Draw a few more sharp, teardrop shaped petals coming from the same area, overlapping behind one another. Some of them can curve downward to the neck.

4. Finish your drawing off by adding detail lines. This is a stiff and upright flower, so draw mostly long, even lines from the base of each petal to the tips, as well as through the top middle of the head. Remember to go with the curves of the petal shapes to help make them look more three-dimensional.

Aloe

Aloe vera
Healing
NATIVE TO SOUTH AFRICA

Aloe is a flowering succulent plant native to South Africa, Madagascar, Jordan, and the Arabian Peninsula. The gel from the aloe vera species has long been used as a skin treatment and in traditional medicine to treat burns. In this lesson, we'll just focus on drawing the plant itself.

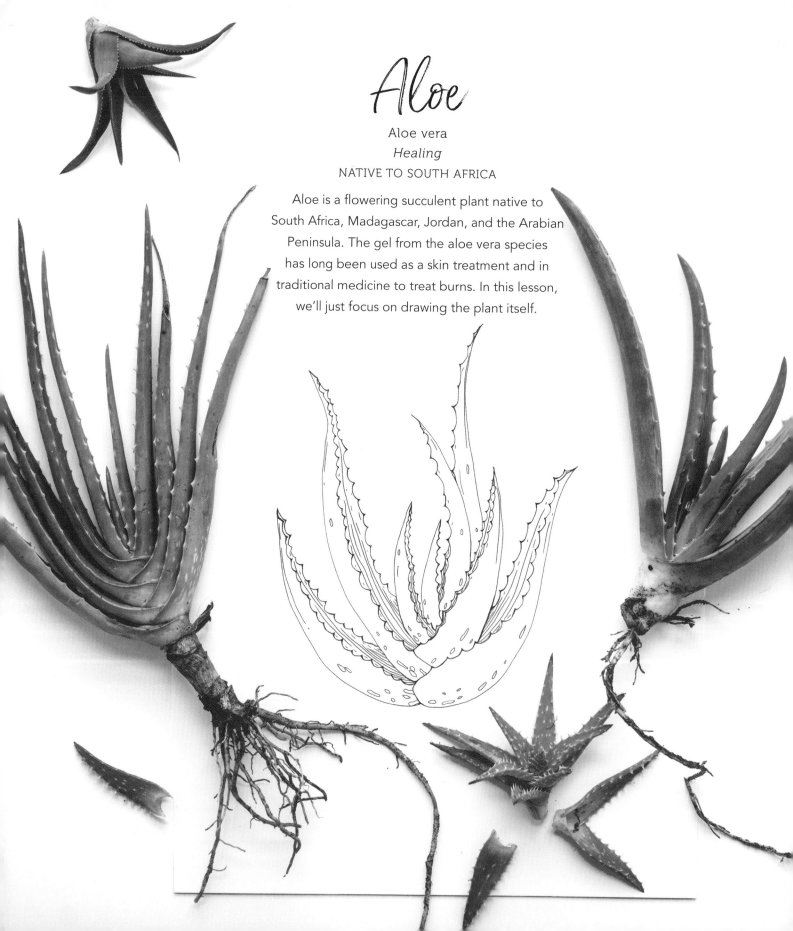

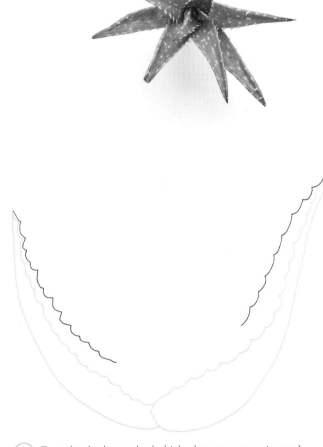

1. Start by drawing the two outermost leaves of the aloe vera plant first. Draw a long, smooth, curving line upward, then complete the inside of the leaf with jagged edges. Mirror that on the other side.

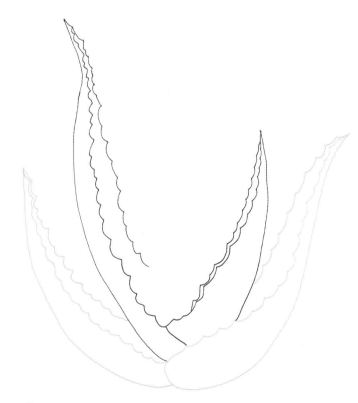

2. To make the leaves look thick, draw two more jagged lines going downward from the tips, placed as shown above. Don't complete the lines yet; leave some space for the next step.

3. In the space that you left in the previous step, draw two more leaves in the same way, with one in front of the other. Leave space for the next set of leaves as you did before.

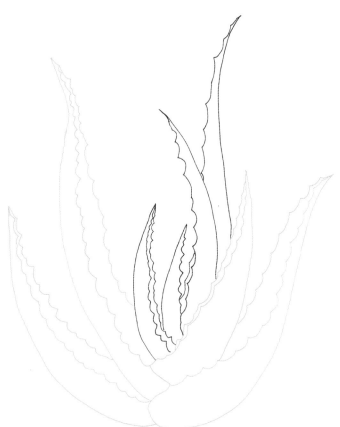

4 Repeat step three until you run out of space and have filled in enough leaves. Let the inner leaves be a little smaller than the rest, and vary the direction of the leaves by curving their tips.

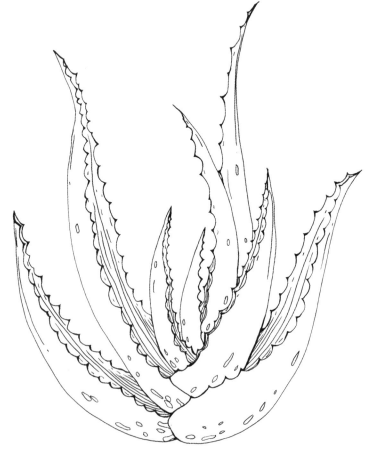

5 Complete the drawing by adding little ovals along the bottoms of all leaves. Next, draw long thin lines running up the center of each leaf and add a few dots here and there. Outline some of the areas where leaves overlap.

King Protea

Protea cynaroides

Enduring

NATIVE TO SOUTH AFRICA

The king protea is the national flower of South Africa. With an impressive flower head bursting with color in crimson and pink, this flower is absolutely stunning—and incredibly resilient. It is tough enough to endure harsh environments, from hot and dry to cold and wet. It has even adapted to bushfires; the king protea relies on them to reproduce.

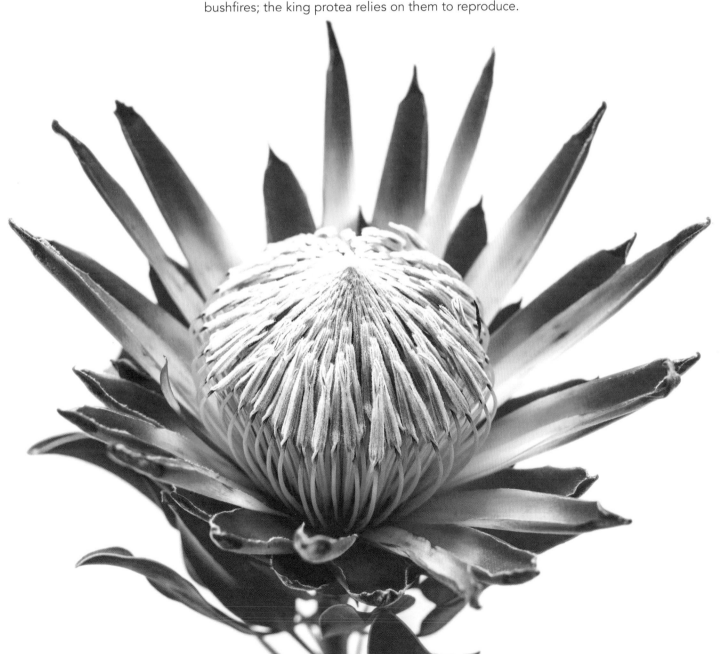

1 Start by drawing a large, soft diamond shape for the flower head. Make the sides rounded.

2 Now we will begin to draw the outer *bracts* of the flower. These bracts are long, tough, bunny-ear shapes that surround the flower head. The first layer we'll draw will look like short rounded triangles layered on top of one another. Draw one inside the bottom middle of the diamond shape, then several more overlapping below the diamond shape.

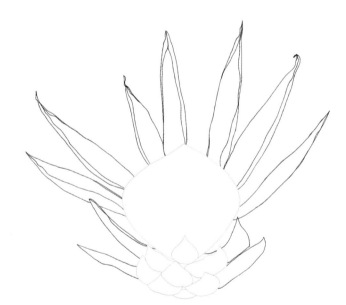

3 Begin to build out the outer bracts of the flower. Because the flower is angled, the stiff, upright bracts become longer as they move around the flower head, coming out from behind it like a starburst. The tips come to a thin point, and some curl inward. To make them look more three-dimensional, draw lines along the sides of a few bracts to show their backsides. The topmost bracts will show two of these lines, similar to a bunny ear.

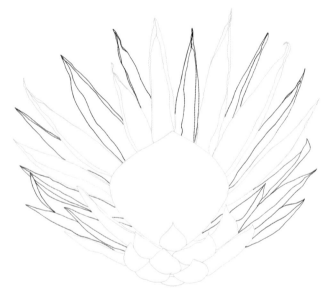

4 Repeat step three to completely fill in all of the outer flower bracts. The flower should look like a wide V-shape, with the bracts coming out of the head from the bottom in all directions.

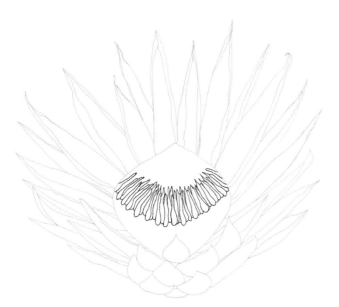

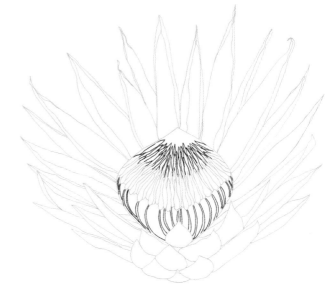

⑤ Now, draw anthers in the middle half of the diamond shape. Start with one, making a shape that is round at the bottom before tapering upward to a thin point, like a stretched-out, wobbly teardrop. From there, draw many more anthers, layering them behind one another until the whole middle is filled in. To make the flower head look three-dimensional, curve the layer of anthers in a U-shape, so that the outer anthers are higher than those on the inside.

⑥ Continue drawing in more anthers above the first layer so that only the top point of the flower head is showing. Follow the U-shape so that the anthers will point toward the top. Next, draw in the filaments below the first layer of anthers by connecting thin lines from each anther to the bottom of the flower head, with the outer filaments curving inward to make the flower look round.

⑦ Fill in the rest of the flower head with more layers of anthers and filaments to complete the flower. Add details by adding one line in the middle of each bract and darkening their tips.

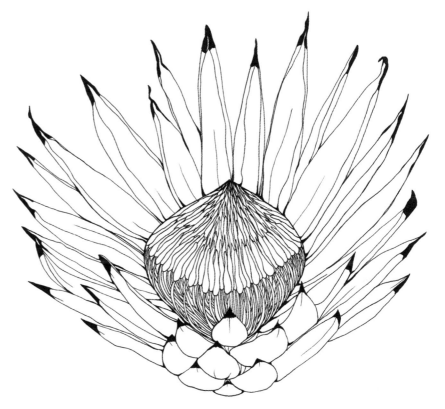

Gerbera Daisy

Gerbera jamesonii
Festive
NATIVE TO SOUTH AFRICA

The gerbera daisy, also known as the African daisy, was first discovered in South Africa and is found in a variety of sizes and a vibrant rainbow of colors. These daisies are a sign of cheerfulness, happiness, and celebration of life. They always turn their heads to follow the sun, no matter which direction they are facing.

Tip

Gerbera daisies have predictably shaped petals, not changing in width too much from the base to the tip. The petals create a symmetrical circle around the center. To maintain this symmetry when drawing, lightly sketch a circle on your paper the same size as the flower you want to draw to use as a guide. Leave the pencil lines there as you draw in the petals so that when you ink them in, they'll all reach an even diameter.

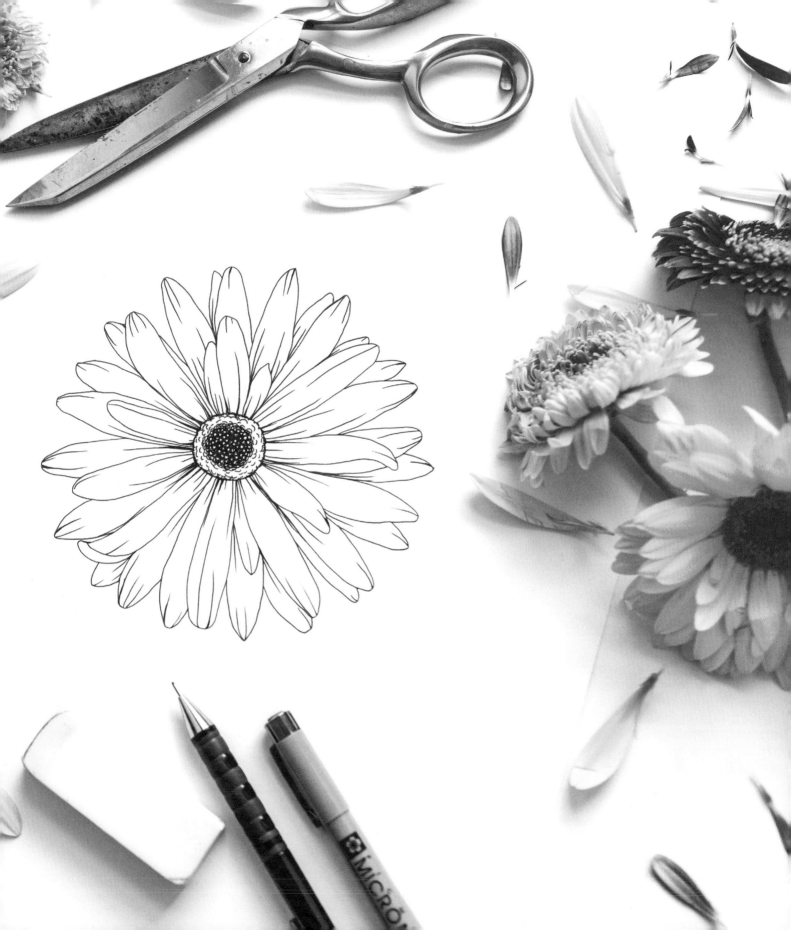

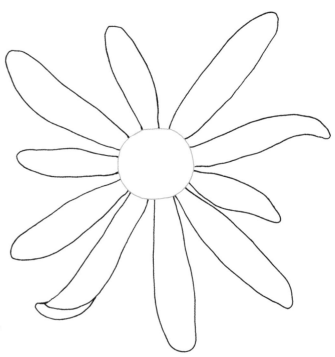

1) Begin by drawing a quarter-sized circle on your page.

2) Draw elongated, rounded petals straight out from the perimeter of the circle and space them equal distances apart. A few can be smaller than others, slightly curved at the tips, or even "folded" over for variety.

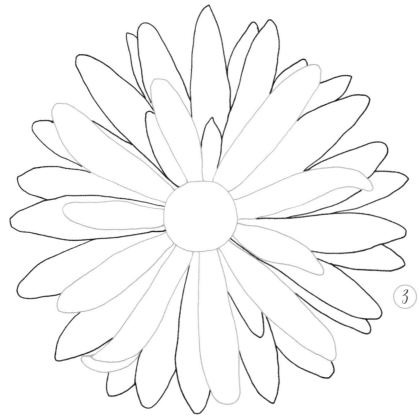

3) Fill in more petals behind the first layer, in the same way as in the previous step. Continue to overlap them until you've created an evenly balanced flower.

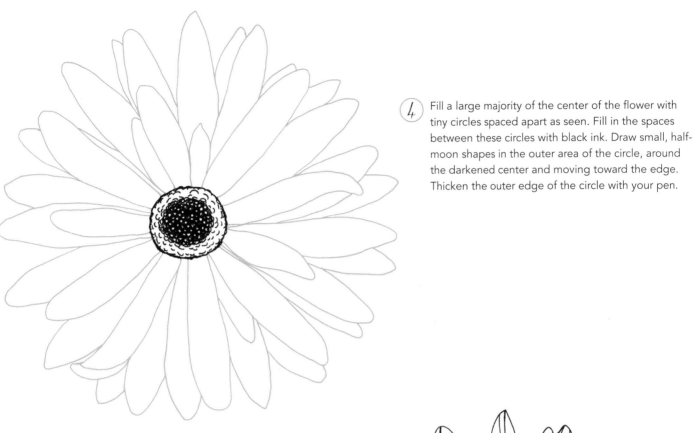

4 Fill a large majority of the center of the flower with tiny circles spaced apart as seen. Fill in the spaces between these circles with black ink. Draw small, half-moon shapes in the outer area of the circle, around the darkened center and moving toward the edge. Thicken the outer edge of the circle with your pen.

5 Add details to your daisy by drawing straight lines going outward from the center circle and moving up into the petals. Vary the lines so that some are shorter and some are longer. Add short lines from the tips of the petals going downward toward the head.

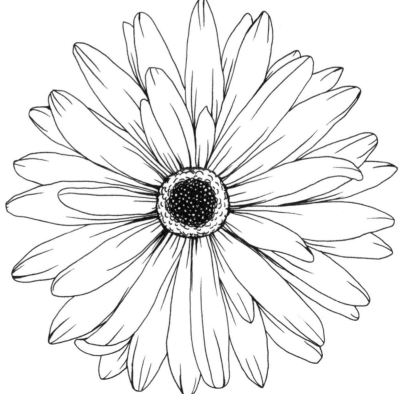

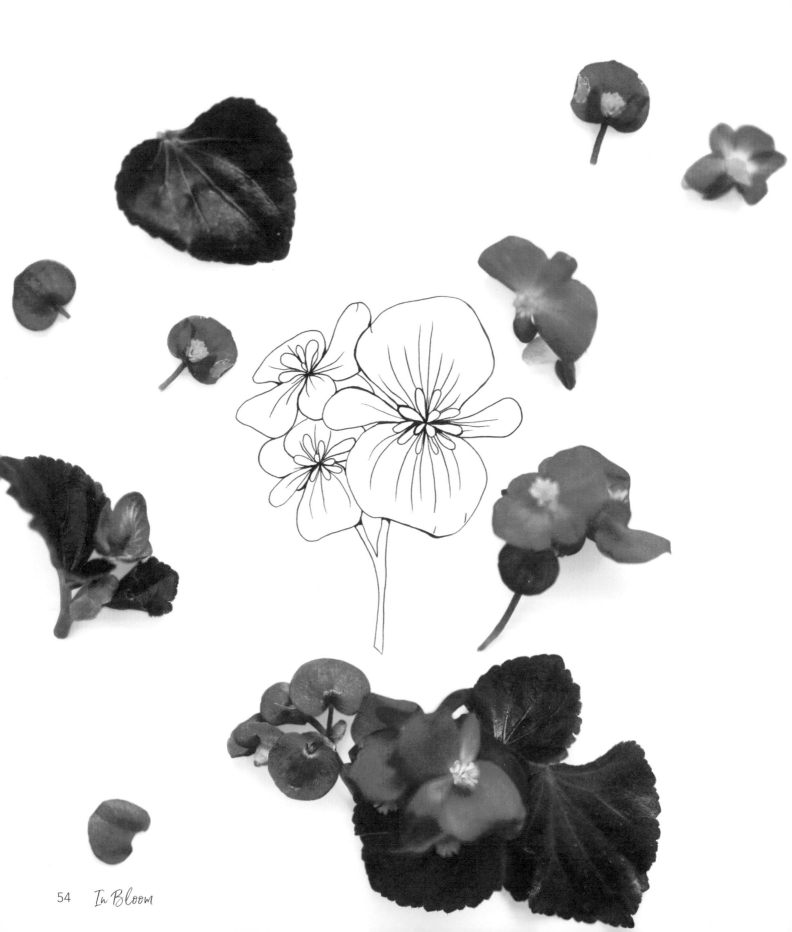

In Bloom

Verdant Asia

Orchid

Camellia

Marigold

Crown of Thorns

Begonia

Chrysanthemum

Stargazer Lily

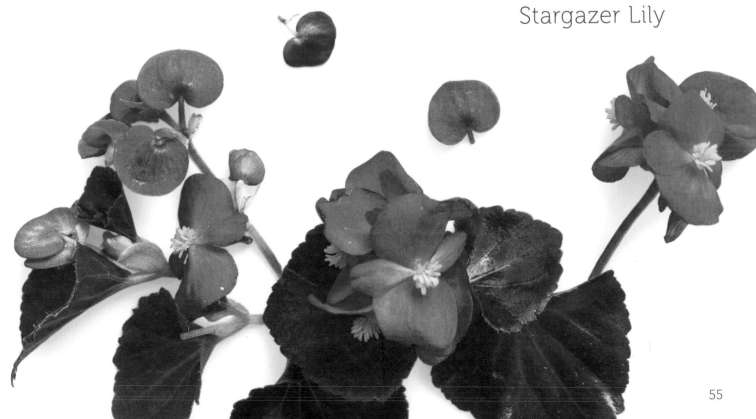

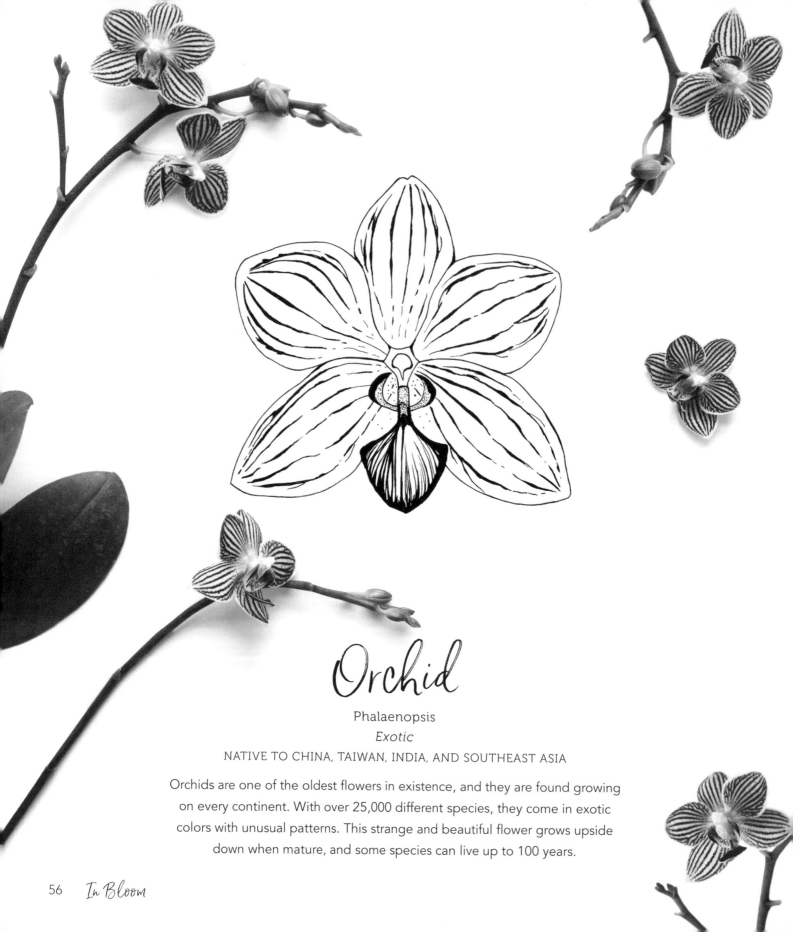

Orchid

Phalaenopsis
Exotic
NATIVE TO CHINA, TAIWAN, INDIA, AND SOUTHEAST ASIA

Orchids are one of the oldest flowers in existence, and they are found growing on every continent. With over 25,000 different species, they come in exotic colors with unusual patterns. This strange and beautiful flower grows upside down when mature, and some species can live up to 100 years.

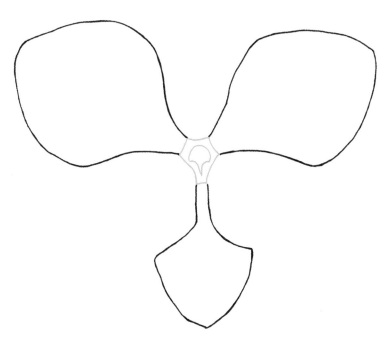

1 Let's start with the center of the orchid. Draw the anther cap, which looks like a tiny mushroom with a tapered stem. Around that, draw what's called the orchid's *column*. Enclose the anther cap with a small stretched hexagon, making the top flat or slightly curved, and the two lines at the bottom of the anther cap longer than the others.

2 Draw two large, spoon-shaped petals coming out from the top sides of the hexagon. They should mirror each other. The bottom petal, or the orchid's "tongue," will come straight down from the bottom of the hexagon. It looks like a small shovel.

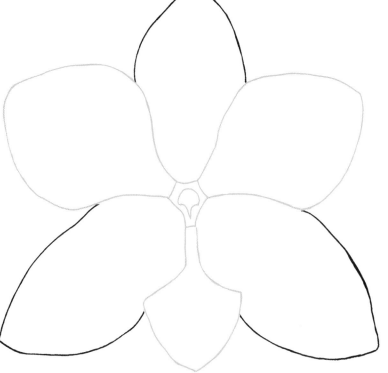

3 Draw three more petals layered behind the first three. The top one will be facing straight up, evenly placed behind the first two top petals. The bottom two are longer and shaped like stretched-out spoons, mirroring each other and pointing slightly downward.

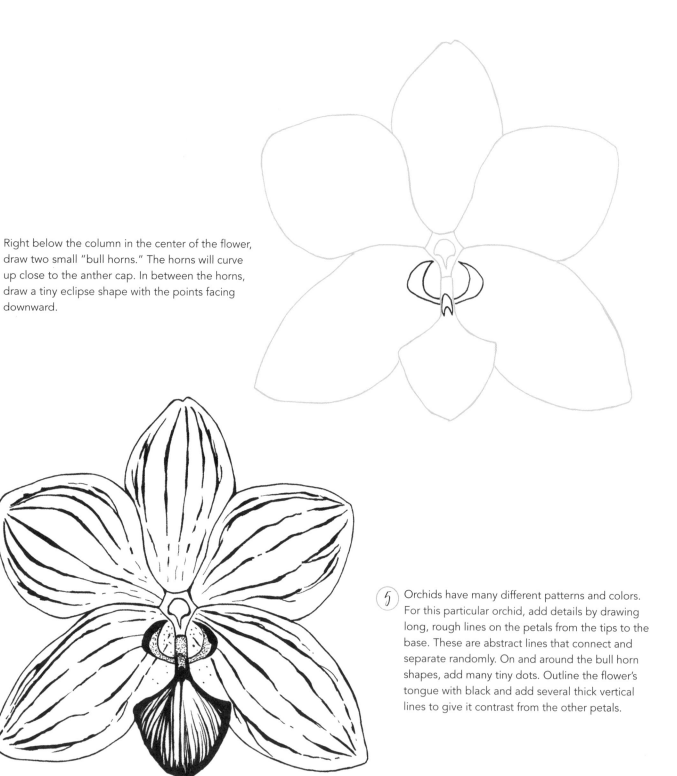

4. Right below the column in the center of the flower, draw two small "bull horns." The horns will curve up close to the anther cap. In between the horns, draw a tiny eclipse shape with the points facing downward.

5. Orchids have many different patterns and colors. For this particular orchid, add details by drawing long, rough lines on the petals from the tips to the base. These are abstract lines that connect and separate randomly. On and around the bull horn shapes, add many tiny dots. Outline the flower's tongue with black and add several thick vertical lines to give it contrast from the other petals.

Camellia

Camellia japonica

Romantic

NATIVE TO CHINA, SOUTH KOREA, TAIWAN, AND JAPAN

Representing eternal love and passion, the camellia is a delicate flower that is highly respected in Japan. It is sometimes called the rose of winter because it blooms when the weather gets cold and when other flowers die off. In China, the flower symbolizes long-lasting love because when the petals fall off, the calyx at the base goes with it, unlike other flowers.

① Start by drawing the stigma in the center of the camellia from an overhead view. It will look like a tiny circle with three little connected leaf shapes in the center.

② Now draw the stamens coming outward in all directions from the stigma. The filaments look like long, thin tubes and the anthers are small circles.

③ Begin to draw big, heart-shaped petals behind the stamens. The edges are very wobbly, as the petals have many wrinkles. Slightly overlap one behind the other.

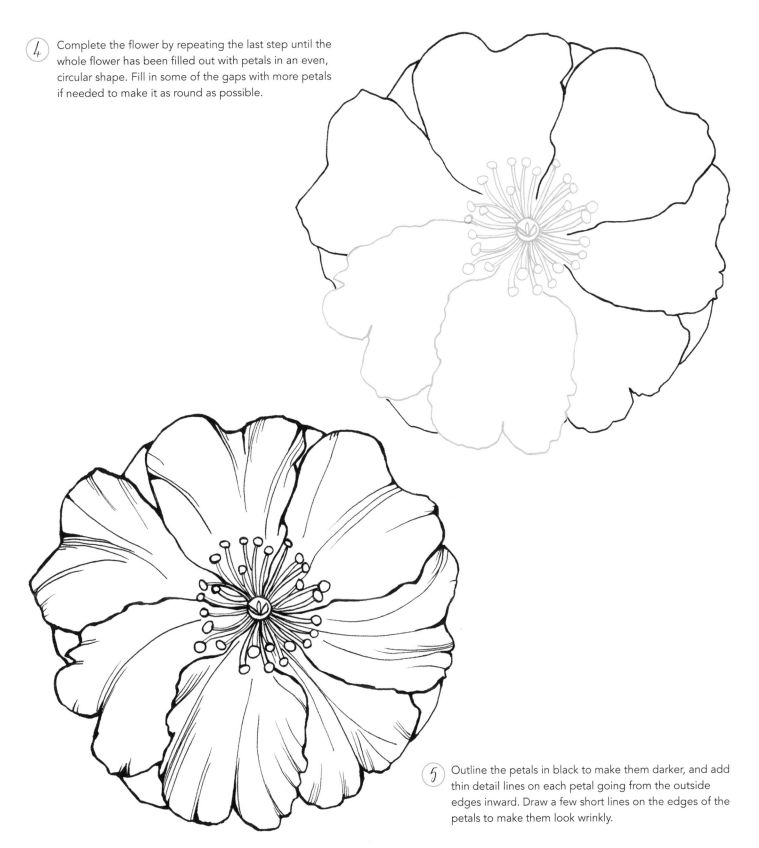

4 Complete the flower by repeating the last step until the whole flower has been filled out with petals in an even, circular shape. Fill in some of the gaps with more petals if needed to make it as round as possible.

5 Outline the petals in black to make them darker, and add thin detail lines on each petal going from the outside edges inward. Draw a few short lines on the edges of the petals to make them look wrinkly.

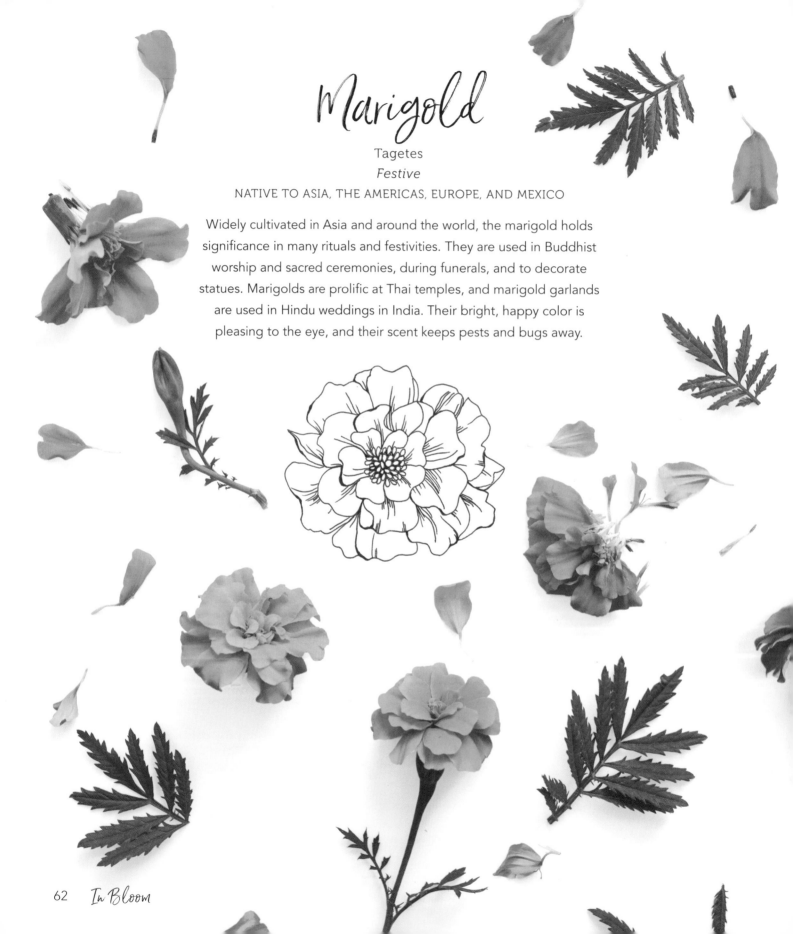

Marigold

Tagetes

Festive

NATIVE TO ASIA, THE AMERICAS, EUROPE, AND MEXICO

Widely cultivated in Asia and around the world, the marigold holds significance in many rituals and festivities. They are used in Buddhist worship and sacred ceremonies, during funerals, and to decorate statues. Marigolds are prolific at Thai temples, and marigold garlands are used in Hindu weddings in India. Their bright, happy color is pleasing to the eye, and their scent keeps pests and bugs away.

1. Begin by drawing a circular cluster of tiny teardrop shapes, all connecting to one another. Start from the center working outward.

2. Next, draw six small petals in loose, half-heart shapes going around the cluster in the center.

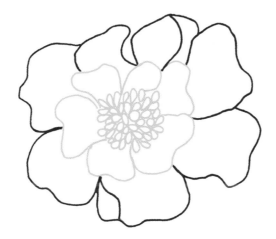

3. Building outward from there, draw several larger petals with rounded wobbly edges. Some can overlap themselves with a curved line going down one portion of a petal.

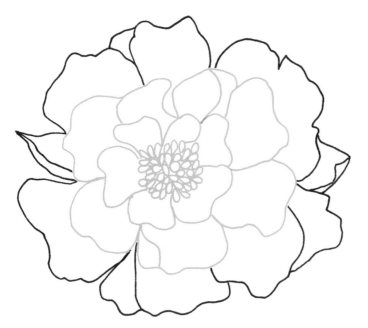

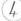 4

Once again, build another layer of petals around the last set, this time with slightly larger petals. Each layer of petals should halfway overlap behind the first. Add a few variations to some petals, like a small tear, or have one or two curled up at the tips.

 5

Add details by adding short, curving lines coming upward from the base of each petal. Remember to follow the petal's curve. Darken some of the petal edges to add contrast.

Crown of Thorns

Euphorbia milii

Wild

NATIVE TO MADAGASCAR

Originally found in Madagascar, the crown of thorns is widely cultivated around Asia, with many hybrids created in Thailand. It is called crown of thorns because legend has it that it is associated with Christ. The plant is sometimes called indestructible because it can survive in extreme dryness. This flowering plant is actually one of the few succulents with real leaves. It is beautifully unique with its spiky stems and brightly colored flowers.

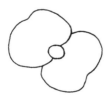

① Start by drawing a small circle for the stigma. Then, draw two slightly overlapping lima-bean shapes for the petals on either side of the stigma.

② Repeat step one by drawing three more flowers in the same way, all close together. One can be overlapped behind the first one, and the farthest one can have stretched-out, flat petals to hint that it is facing in a different direction.

Tip

From each stem, bracts of four small flowers branch out together. We'll draw the whole stem, leaves, and flowers to capture the uniqueness of the plant.

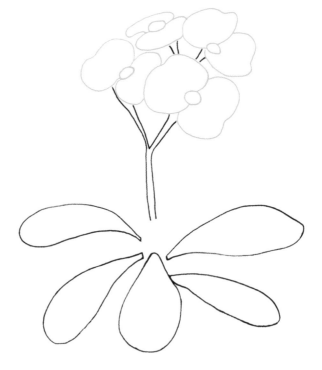

③ Now connect the flower bracts with one stem coming from each flower and all coming together into a thin stem. Next, begin to draw the leaves by creating large, curving teardrop shapes. They will come out of the plant in different directions like a fountain, though they are not attached to anything yet. Leave a little space between the flower stem and the leaves for the next step.

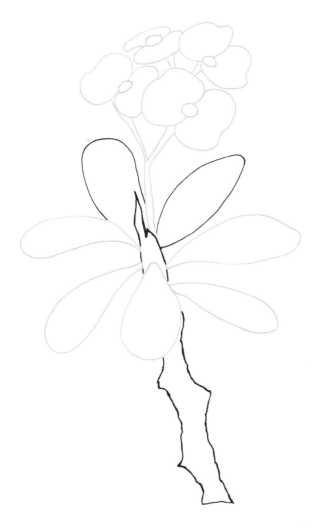

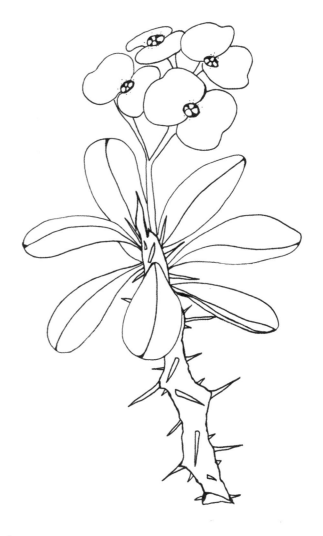

④ Now, draw a rough, thick stem to connect all of the leaves in the middle. Finish it with a few pointy mountain shapes at the top and along the sides. Add two more leaves shooting upward and overlapping behind that stem.

⑤ Add a generous number of thorns to the stem going in all directions, with some coming straight out from the mountain points at the top of the thick stem. Draw long, stretched-out triangles for the thorns. Draw a line down the middle of each leaf for detail, and fill in the center of the stigmas with four little circles. Fill in the gaps black.

Begonia

Begoniaceae

Enduring

NATIVE TO ASIA, SOUTH AMERICA, AND TROPICAL RAINFORESTS

Begonias are easy to grow and can be propagated from leaves or stems. Their succulent stems also make them drought tolerant. Native to Asia, South America, and many tropical rainforests, the begonia grows in many varieties and colors. This lush, ornamental flower is thought to have been used to polish Japanese swords long ago.

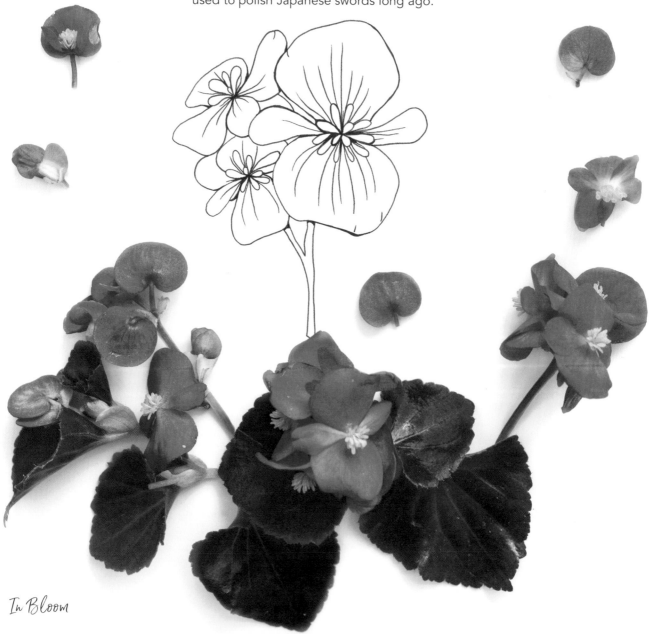

NOTE: Several begonia flowers grow on one stem, so we'll draw the whole bunch together to capture the whole begonia.

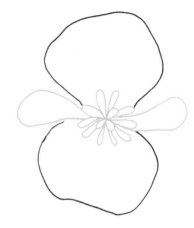

① Draw the tiny stamens of the flower by creating a small bunch of elongated teardrop shapes connected to one another in the center.

② Draw two small, rounded petals coming out from the stamens horizontally.

③ Now draw two large petals on the top and bottom of the flower. They are soft rounded ovals.

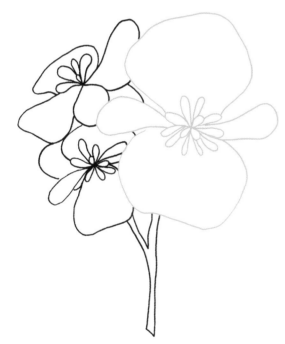

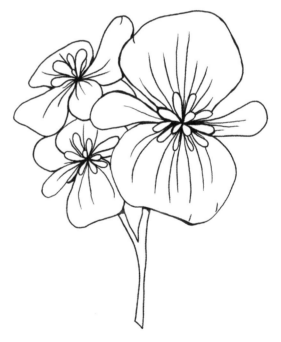

④ Complete the flower bunch by drawing two more flowers in the same way. Overlap them so they are behind the first flower, and angle one of the flowers in a different direction for more realism. Draw short, narrow stems coming down from the base of the flowers, then connect all three flowers with one longer stem.

⑤ To add in the details, draw lines coming upward from the center of the flowers, curving with the shape of the petals.

Chrysanthemum

Chrysanthemum

Healing

NATIVE TO EAST ASIA

The chrysanthemum was first cultivated in China, and it is
the Imperial Seal of Japan. The flower is a natural source of
insecticide and has medicinal properties. Chrysanthemum tea is
used to aid in flu symptoms, has anti-inflammatory potential, is
antibacterial, and can help with heatstroke and fever due to its
cooling properties. It also has the ability to reduce
indoor air pollution.

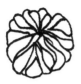

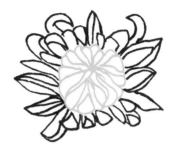

1 Start with the inner petals of the flower. Draw tiny teardrop shapes with the tips pointing toward the center in a circle. If needed, sketch a small circle as a guide to keep a rounded shape.

2 Now begin to draw tiny petals opening up from the outer edge of the center petals. They are shaped like bunny ears, with lines in the center to indicate that they are folded inward. The petals facing you should curve upward like rounded triangles overlapping themselves. Some of the petals can be hooked or curled at the tip for variety.

3 Going around the center, draw a layer of larger petals and begin to layer them behind one another. Continue creating the same bunny-ear shape as used previously, with inner lines to show that each petal folds inward.

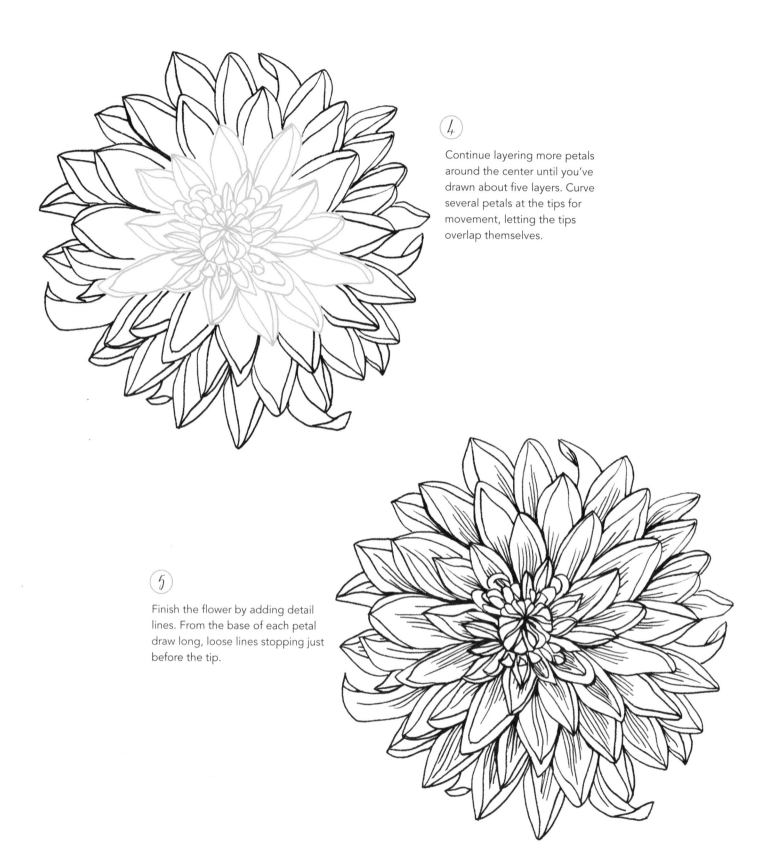

4

Continue layering more petals around the center until you've drawn about five layers. Curve several petals at the tips for movement, letting the tips overlap themselves.

5

Finish the flower by adding detail lines. From the base of each petal draw long, loose lines stopping just before the tip.

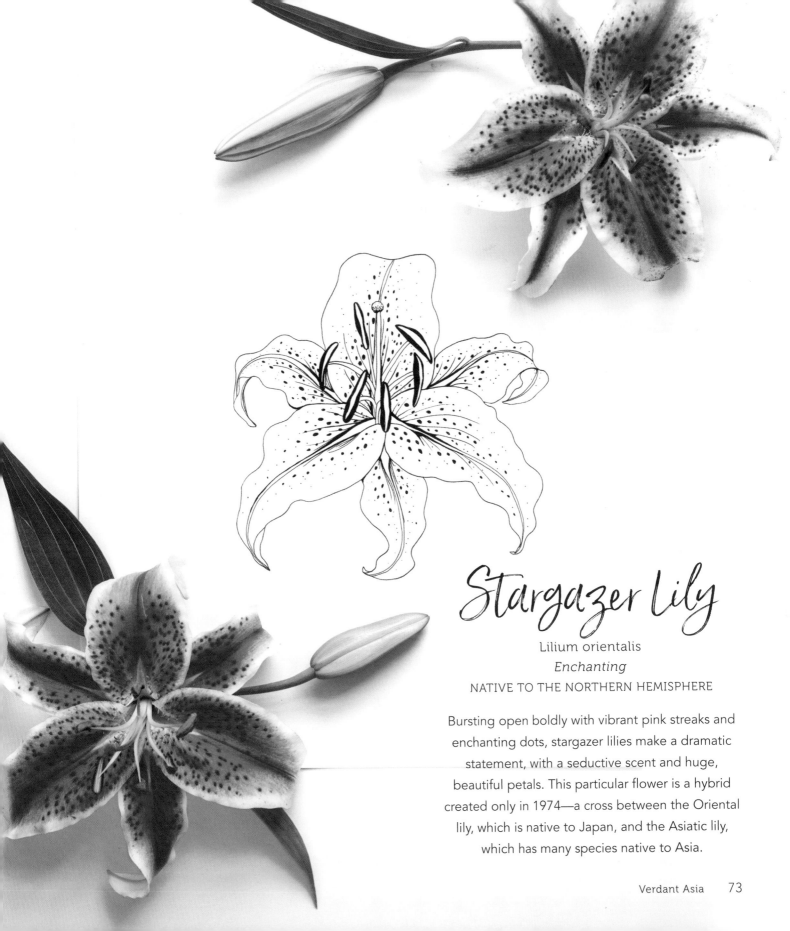

Stargazer Lily

Lilium orientalis
Enchanting
NATIVE TO THE NORTHERN HEMISPHERE

Bursting open boldly with vibrant pink streaks and enchanting dots, stargazer lilies make a dramatic statement, with a seductive scent and huge, beautiful petals. This particular flower is a hybrid created only in 1974—a cross between the Oriental lily, which is native to Japan, and the Asiatic lily, which has many species native to Asia.

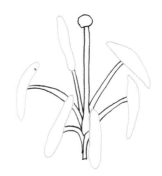

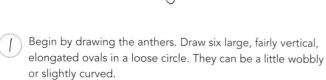

(1) Begin by drawing the anthers. Draw six large, fairly vertical, elongated ovals in a loose circle. They can be a little wobbly or slightly curved.

(2) Next, draw in the filaments, connecting the anthers with long columns that come together at one point. Draw the stigma coming from the center of all of the stamens, shooting upward with a spherical top.

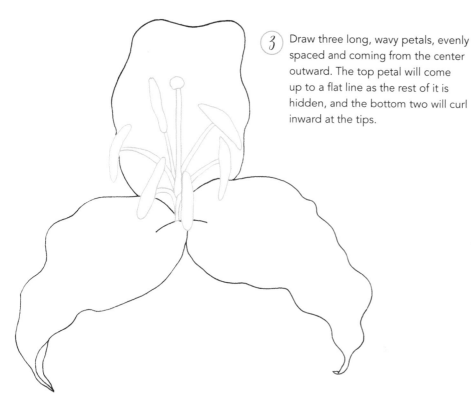

(3) Draw three long, wavy petals, evenly spaced and coming from the center outward. The top petal will come up to a flat line as the rest of it is hidden, and the bottom two will curl inward at the tips.

Tip

Drawing this flower from a slight angle is helpful, because it is easier to see the stamens and stigma.

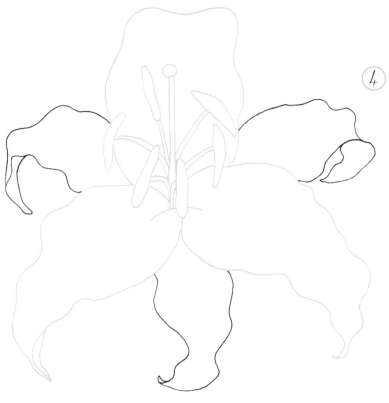

4 Draw three more evenly spaced petals in between the first three. They should be wavy and slightly smaller in size. Once again, draw the tips so that they curve inward, showing the underside of the petal.

5 Add detail by outlining the inside of the anthers in black, leaving the middle white. Draw thick veins down the center of each petal, following the petal's curve. Add a few more lines on the base of each petal going outward. Dot the petals with large dots, and then add small dots around most of the petals, avoiding the inner edges.

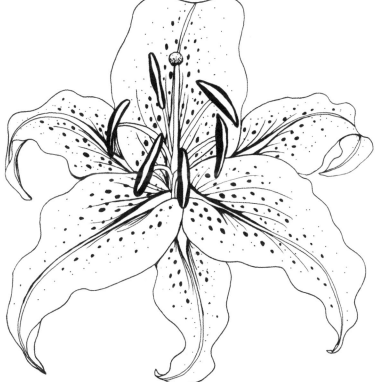

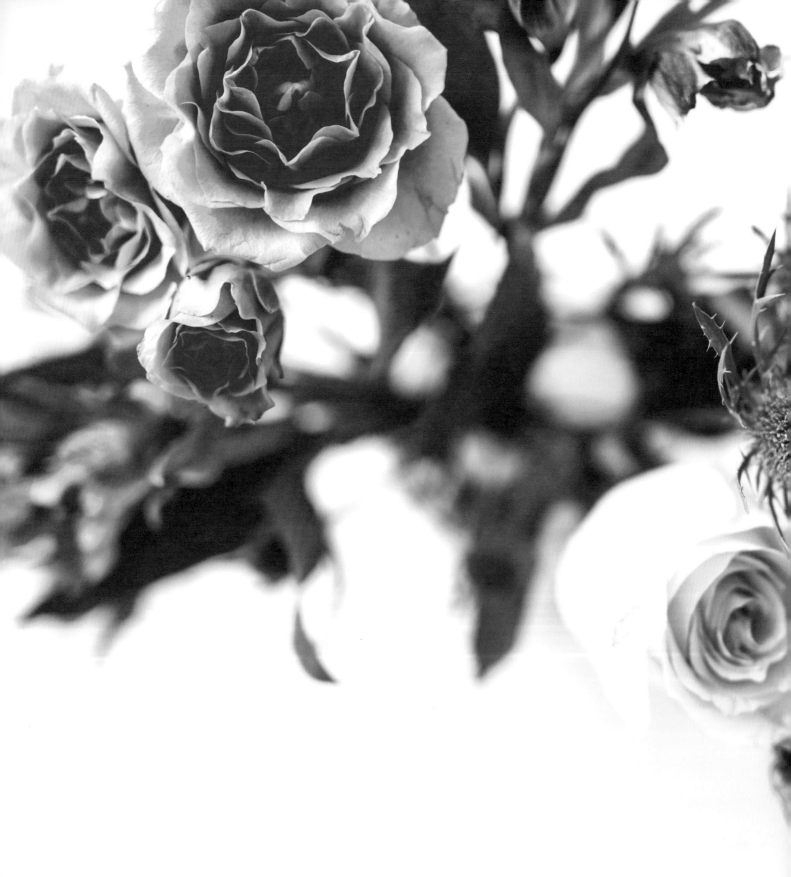

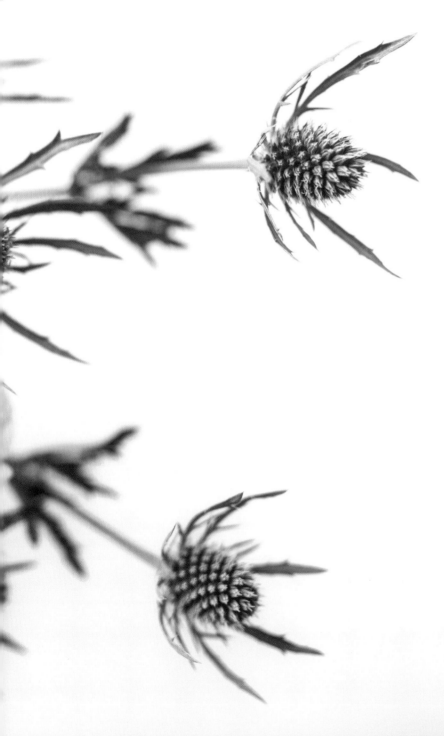

Lush Europe

Bells of Ireland

Chamomile

Tulip

Rose

Sea Holly

Carnation

Gladiolus

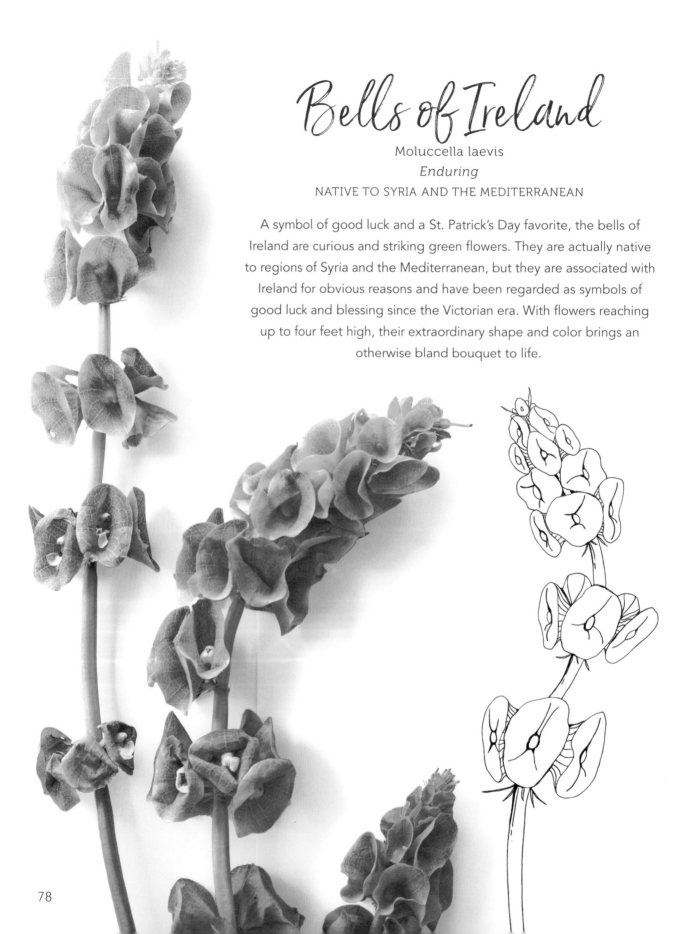

Bells of Ireland

Moluccella laevis

Enduring

NATIVE TO SYRIA AND THE MEDITERRANEAN

A symbol of good luck and a St. Patrick's Day favorite, the bells of Ireland are curious and striking green flowers. They are actually native to regions of Syria and the Mediterranean, but they are associated with Ireland for obvious reasons and have been regarded as symbols of good luck and blessing since the Victorian era. With flowers reaching up to four feet high, their extraordinary shape and color brings an otherwise bland bouquet to life.

1 Using a pencil, draw a long, slightly curving line down the middle of your paper. You'll use this as a guide and erase it later.

2 Draw four wobbly circles spread out down the middle of your line. The circles should get a little smaller toward the top.

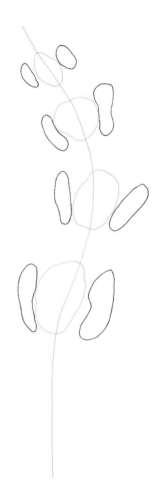

3 Now draw "elephant ears" on each circle as shown. They can be touching, or slightly spaced away from the circles.

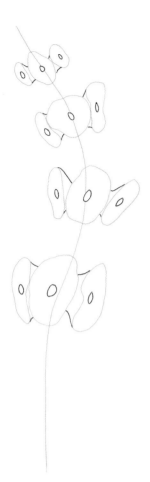

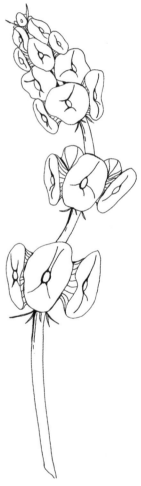

4 Connect the elephant ears to the center circles with lines that curve inward on the top and bottom. Draw small ovals in the center of every circle and ear.

5 Fill in the top two sections of bells with more bells, getting smaller as you reach the top. They should be stacked slightly behind one another. The very top bell will be the smallest. Draw two round "hills" behind the cluster of bells that are second to bottom to finish off the shape. Now, draw a stem that follows the middle of the pencil line, erasing the line when you're finished.

6 Add details by drawing a few curving lines coming out from the center ovals of each bell. In the area where you connected the elephant ears, draw horizontal lines going with the curve of the shape. Under each section of bells, add short little spikes going downward, and two more at the very top sticking upward.

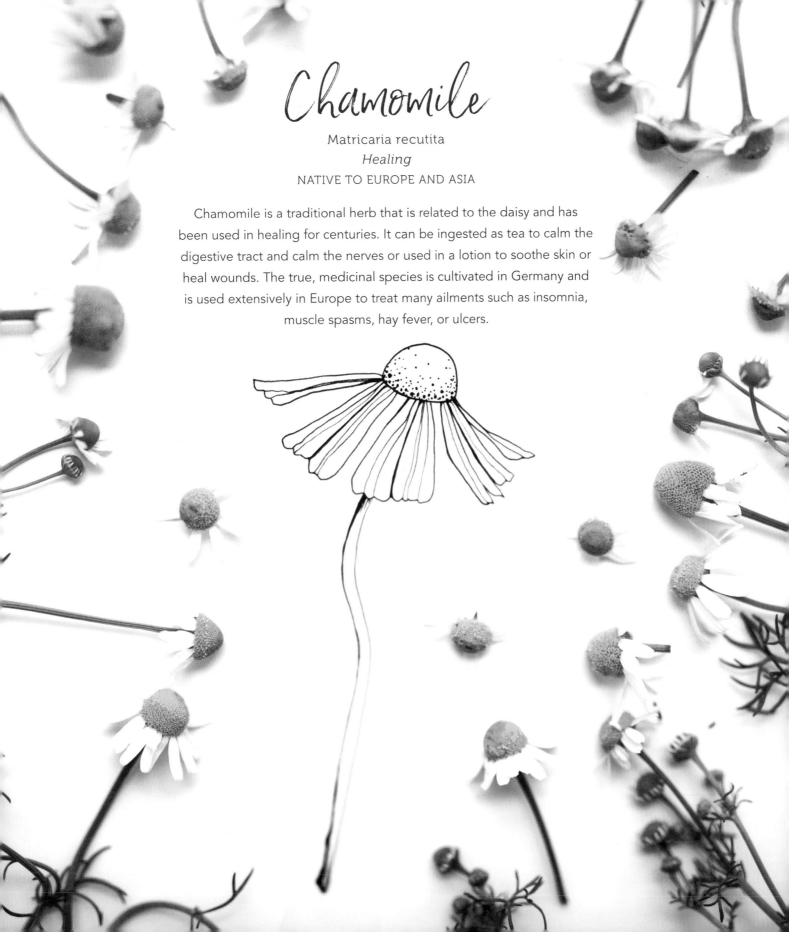

Chamomile

Matricaria recutita
Healing
NATIVE TO EUROPE AND ASIA

Chamomile is a traditional herb that is related to the daisy and has been used in healing for centuries. It can be ingested as tea to calm the digestive tract and calm the nerves or used in a lotion to soothe skin or heal wounds. The true, medicinal species is cultivated in Germany and is used extensively in Europe to treat many ailments such as insomnia, muscle spasms, hay fever, or ulcers.

① Draw a small gumdrop shape for the head of the flower.

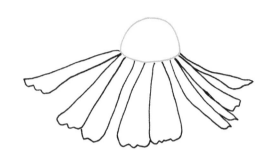

② Chamomile has small sparse petals that usually grow downward and away from the head. Draw a few thin, delicate oval-shaped petals with wavy tips.

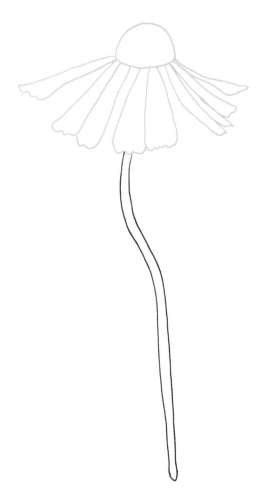

③ Draw the stem by creating two long, thin, slightly curved lines coming from under the petals and connect them at the ends.

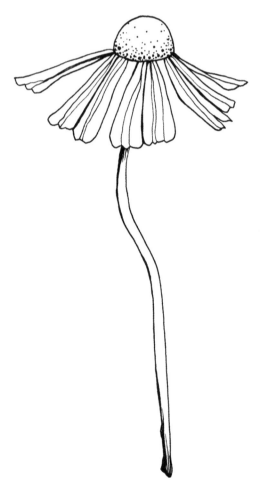

④ Add in some details by making tiny dots at the bottom of the flower head. They should be close together at the base, then spaced out toward the top. Draw lines into the petals from one end to the other, and darken the areas where lines overlap.

Tulip

Tulipa

Enchanting

NATIVE TO EUROPE AND CHINA

The word *tulip* comes from the Persian word for turban. It was fashionable in the Ottoman Empire to wear the flower on one's turban. The origination of tulips can be traced back to Southern Europe and Asia, being naturalized in Persia and Turkey. Tulips became highly prized in the Netherlands in the 1600s because of their enchanting beauty, selling at extremely high prices.

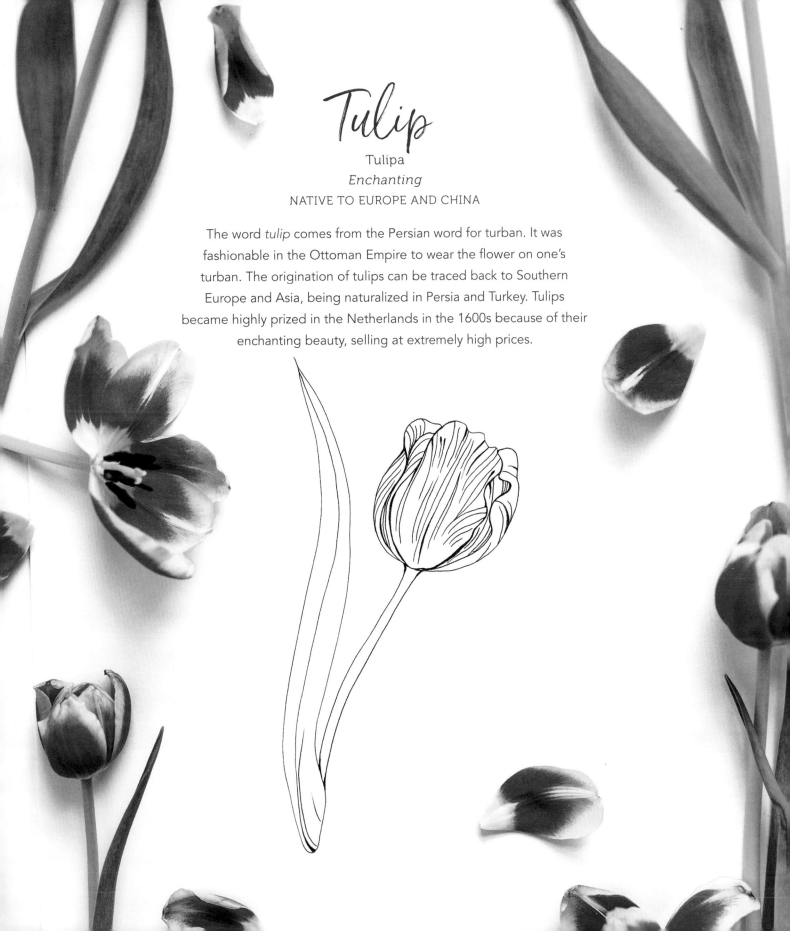

1. Start by drawing a vertical, oblong cloud shape with a few wavy edges and a rounded bottom.

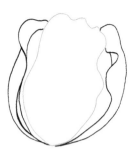

2. Next, draw two petals on either side of the first petal to create the classic tulip shape. Starting from the bottom middle of the first petal, draw softly curving lines upward. They should curve inward to make the whole shape of the flower round, like two hands cupped together with fingertips touching. The tips and inside edges of the petals can be a little wavy.

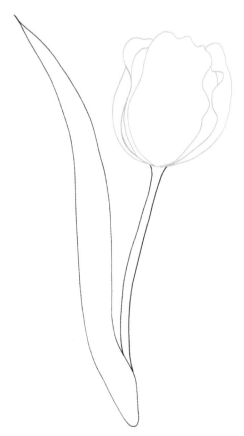

3. To complete the flower, draw a long, thin stem coming from the middle bottom of the flower and curving downward. The leaves of the tulip mimic the soft curve of the stem, pointing away in the other direction. Starting at the bottom of the stem, draw one long leaf a little higher than the top of the flower, tapering at the top.

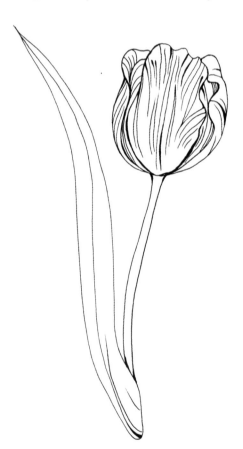

4. Add details by drawing one long line down the middle of the leaf and a variety of delicate vertical lines in the petals. Thicken the outer petal lines to distinguish the detail lines from the petals.

Rose

Rosa

Romantic

NATIVE TO THE NORTHERN HEMISPHERE

Being the most popular flower in the world, the rose has a lengthy history and holds deep meaning and symbolism in many countries. It represents love, beauty, and war. It was first cultivated in China, though its popularity surged in Europe. In the Roman period, it was used as confetti for celebrations, as perfume, and for medicinal purposes. In England, it was a wartime symbol. Today, there are more than 30,000 varieties of roses worldwide.

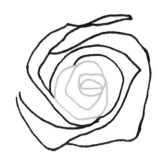

① To draw a rose, start with the innermost folds of the petals. Draw a small coffee-bean shape with a line down the middle. From there, add several more small folds in a circle around it.

② Continue drawing more folds of petals, getting larger and larger with each layer. The layers will look like thin mountain shapes coming to a soft point and curving around one another in a circle.

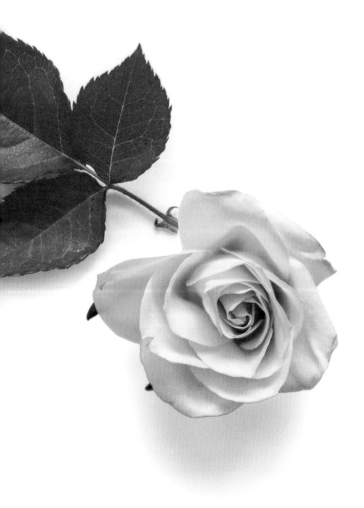

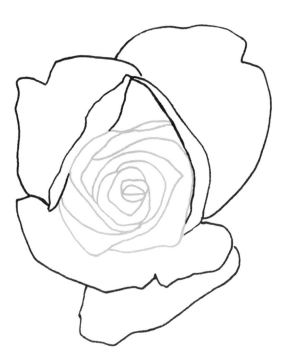

③ Now draw the next layer of petals with larger mountain shapes. The rose folds are now opening up, so draw large petals with a few jagged sections at the top. These are fairly abstract shapes, so you can be liberal about adding variations.

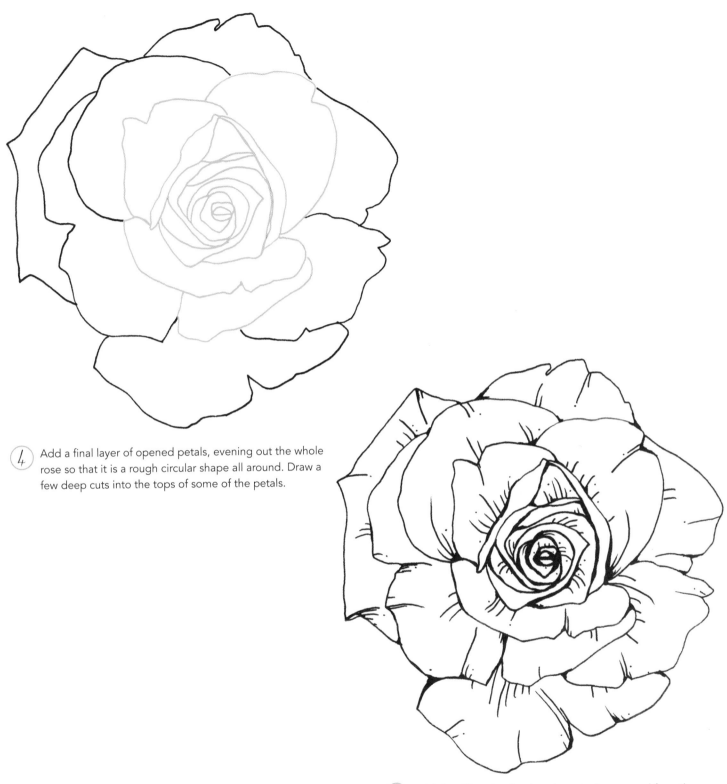

4 Add a final layer of opened petals, evening out the whole rose so that it is a rough circular shape all around. Draw a few deep cuts into the tops of some of the petals.

5 Add detail lines by drawing short strokes upward from the base of each petal, as well as downward in varying lengths from the tips of the petals. Outline and darken the petal lines where they overlap to create contrast.

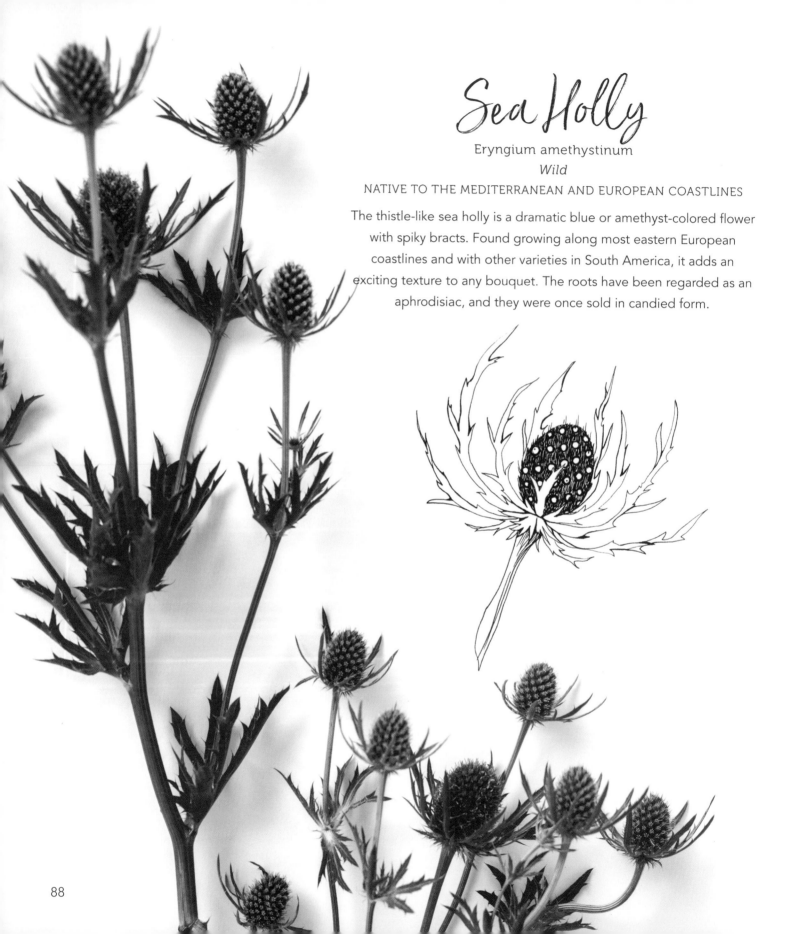

Sea Holly

Eryngium amethystinum

Wild

NATIVE TO THE MEDITERRANEAN AND EUROPEAN COASTLINES

The thistle-like sea holly is a dramatic blue or amethyst-colored flower with spiky bracts. Found growing along most eastern European coastlines and with other varieties in South America, it adds an exciting texture to any bouquet. The roots have been regarded as an aphrodisiac, and they were once sold in candied form.

① Start by drawing the flower head as a small egg shape with the bottom left unfinished.

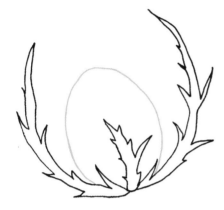

② Surround the egg shape with three very thin, spiky leaves. Place two long leaves curving upward on each side of the egg shape followed by a shorter spiky leaf in the middle.

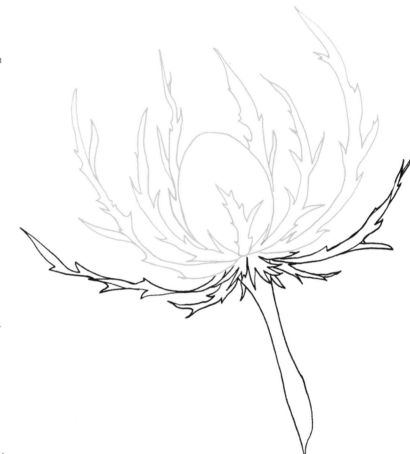

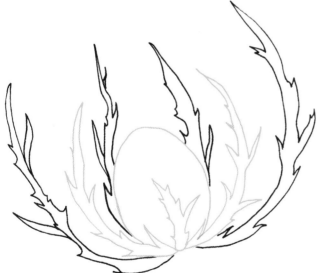

③ Add four more thin, spiky leaves around the flower head. Layer two behind the flower head and place the other two on the sides, making them taller than the rest.

④ Add a lower layer of leaves beneath the flower head, with two long leaves coming outward and upward on the sides and a few smaller spiky leaves in the center. Draw the stem below these layers.

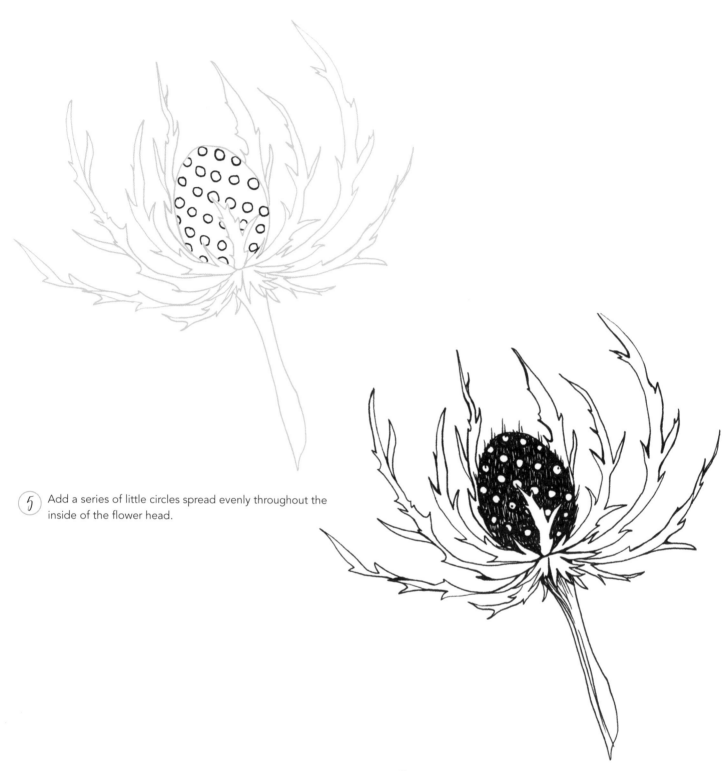

5 Add a series of little circles spread evenly throughout the inside of the flower head.

6 Now, roughly fill in the flower head with black, leaving the circles white. Add a series of long lines running down the stem for additional detail, then add short lines coming upward from the flower head to make it look spiky.

Carnation

Dianthus caryophyllus
Festive
NATIVE TO THE MEDITERRANEAN

Cultivated as long as 2,000 years ago in the Mediterranean region, carnations have long held symbolism for a myriad of occasions, with each color having a different meaning. The name is thought to be derived from the word *incarnation*, meaning "God in the flesh," and legend has it that carnations sprung up from Mary's tears at Christ's crucifixion. Whether given as a first anniversary gift or worn in a boutonniere, for Mother's Day, graduations, Chinese wedding ceremonies, or for political reasons, carnations are a popular choice.

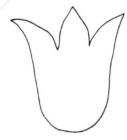

Tip

Carnations are best drawn from the side to see more of their shape, rather than from the top.

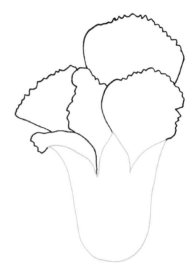

①　Begin by drawing an upside-down bell shape with three points at the top.

②　Between the openings of the points, draw petals coming outward and upward in uneven, rounded shapes with jagged edges. Begin layering more petals behind one another in the same way.

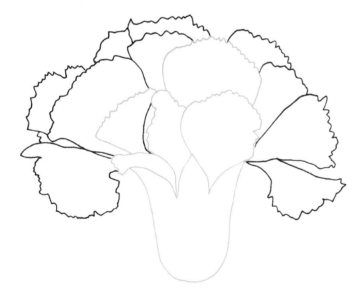

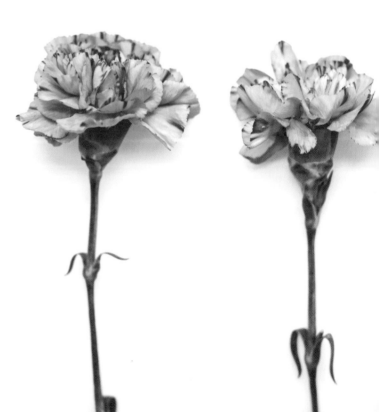

③　Continue to overlap the petals, layering more and more behind the ones you've just drawn. Let some of the petals fall to the sides in a fountain shape.

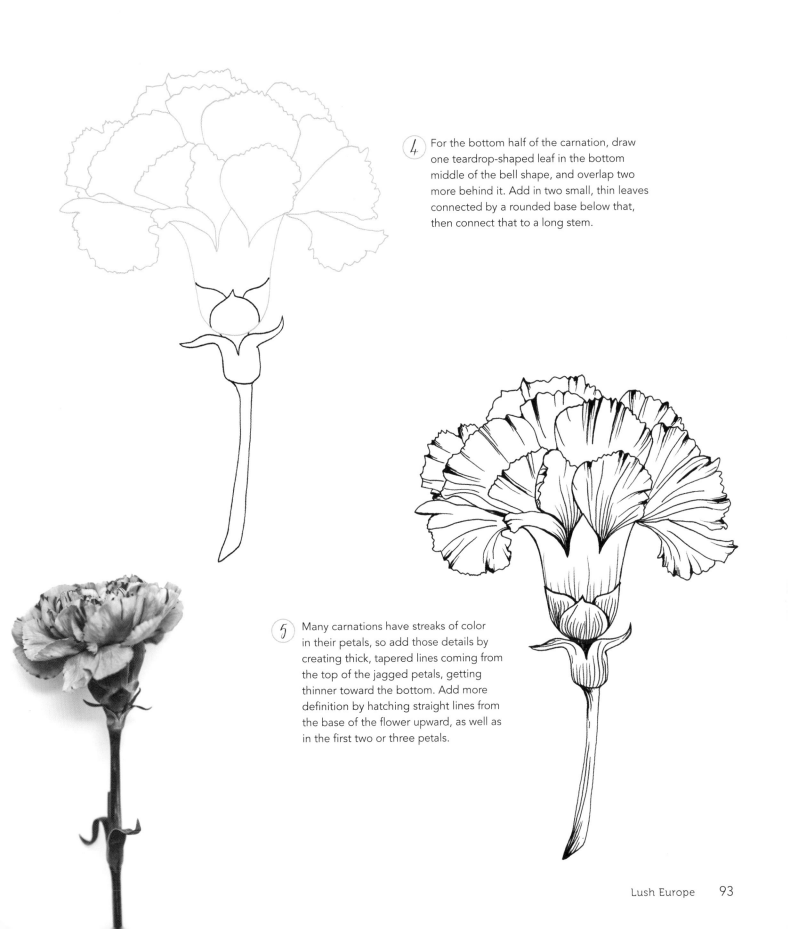

4 For the bottom half of the carnation, draw one teardrop-shaped leaf in the bottom middle of the bell shape, and overlap two more behind it. Add in two small, thin leaves connected by a rounded base below that, then connect that to a long stem.

5 Many carnations have streaks of color in their petals, so add those details by creating thick, tapered lines coming from the top of the jagged petals, getting thinner toward the bottom. Add more definition by hatching straight lines from the base of the flower upward, as well as in the first two or three petals.

Gladiolus

Gladiolus dalenii

Exotic

NATIVE TO THE MEDITERRANEAN AND AFRICA

Gladiolus comes from the Latin word *gladius*, which means "sword." This stunning flower is associated with gladiators, as the long pointed shape of the flower resembles a sharp sword. Symbolizing strength, infatuation, and passion, it was used as a symbol of protection during the gladiator era.

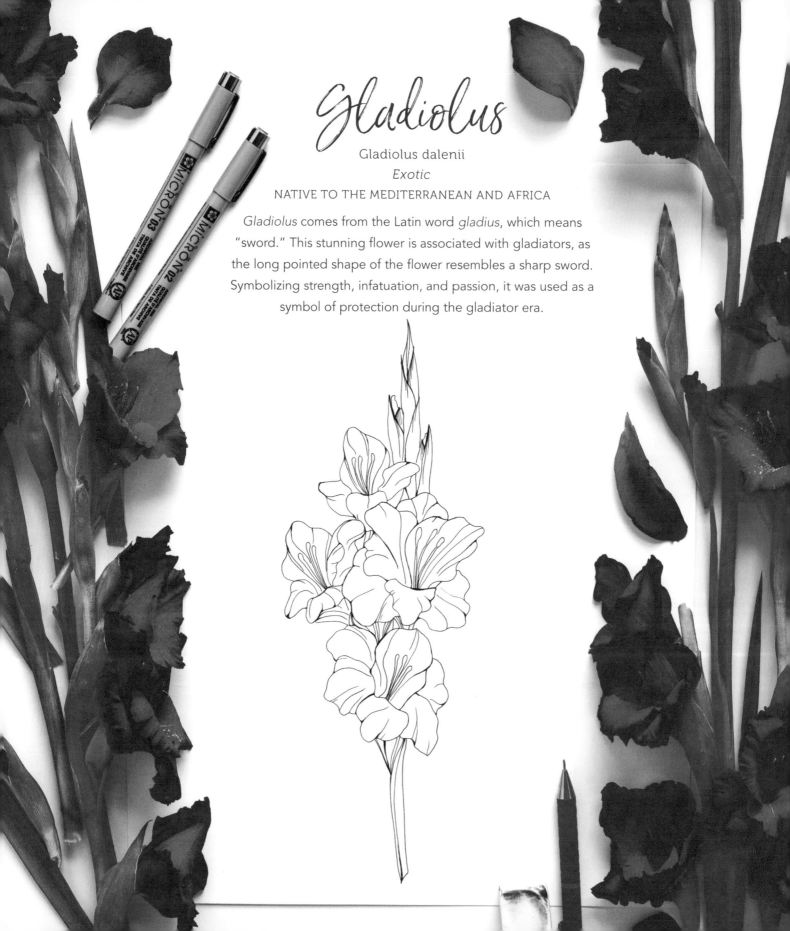

1 To draw a whole gladiolus stalk, start
with one bloom first. Begin by drawing a
tongue shape—an upside-down triangle
with wavy edges.

2 Next, draw a large wavy petal above the
initial shape, overlapping it behind in the
middle. Mirror that same petal overlapped
on the left side.

3 Draw three more wavy petals overlapping
behind the first three. Place one in the
middle above the first two large petals,
then two lower petals on opposite sides.

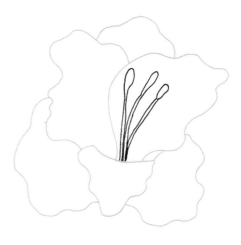

4 Draw three stamens coming upward from
the middle petal. Draw the anthers as
slightly larger oval shapes.

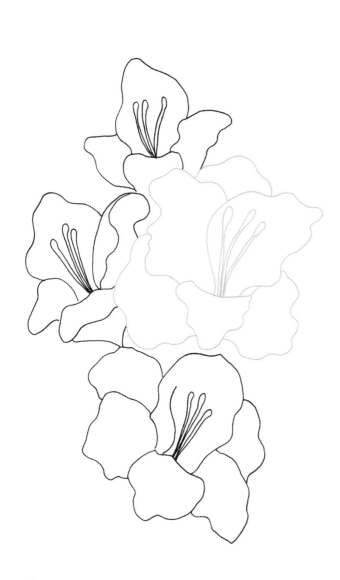

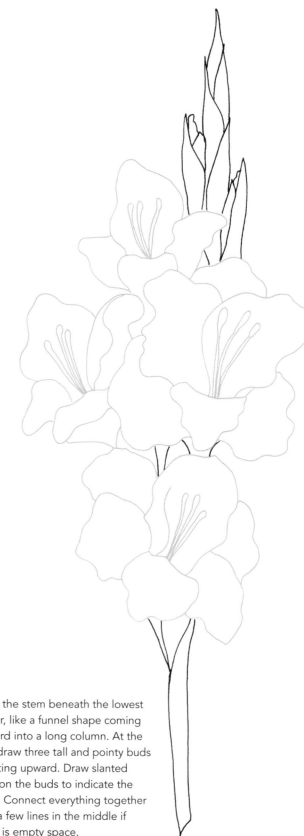

5 Repeat steps one through four to create three more blooms. Layer them slightly behind one another, stacked vertically.

6 Draw the stem beneath the lowest flower, like a funnel shape coming upward into a long column. At the top, draw three tall and pointy buds shooting upward. Draw slanted lines on the buds to indicate the folds. Connect everything together with a few lines in the middle if there is empty space.

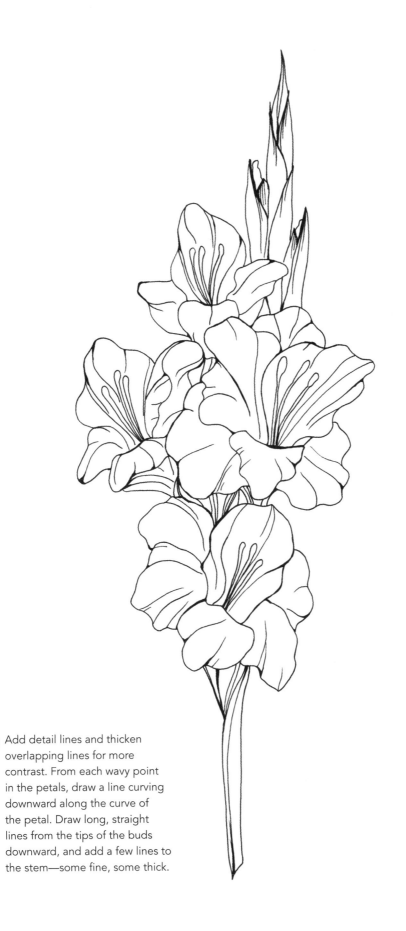

7 Add detail lines and thicken overlapping lines for more contrast. From each wavy point in the petals, draw a line curving downward along the curve of the petal. Draw long, straight lines from the tips of the buds downward, and add a few lines to the stem—some fine, some thick.

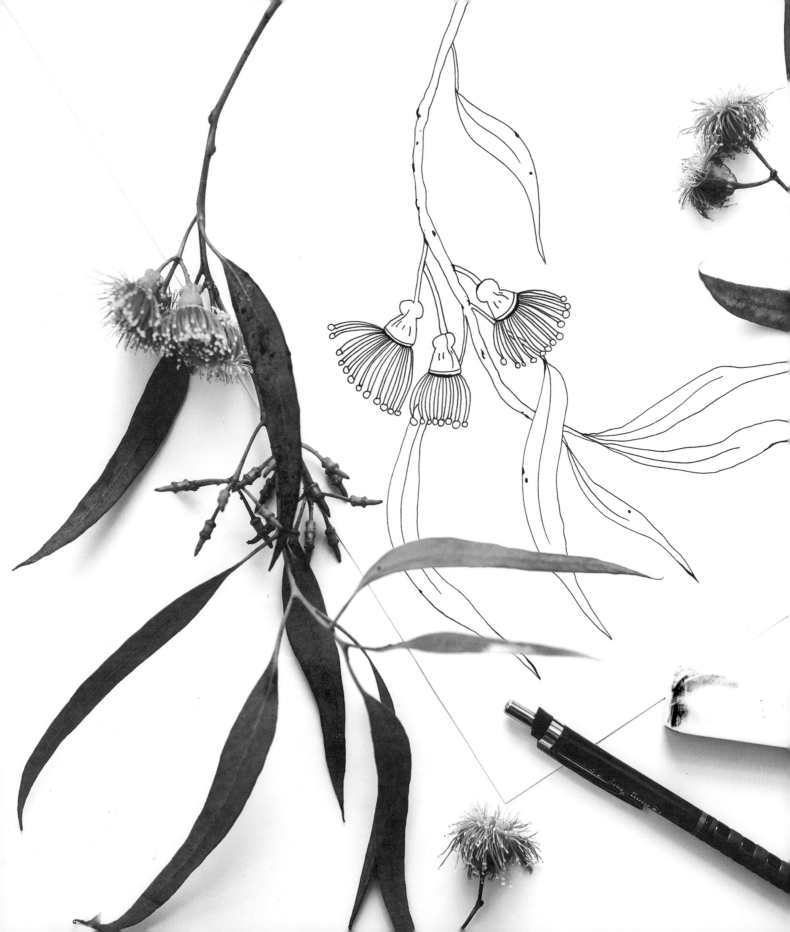

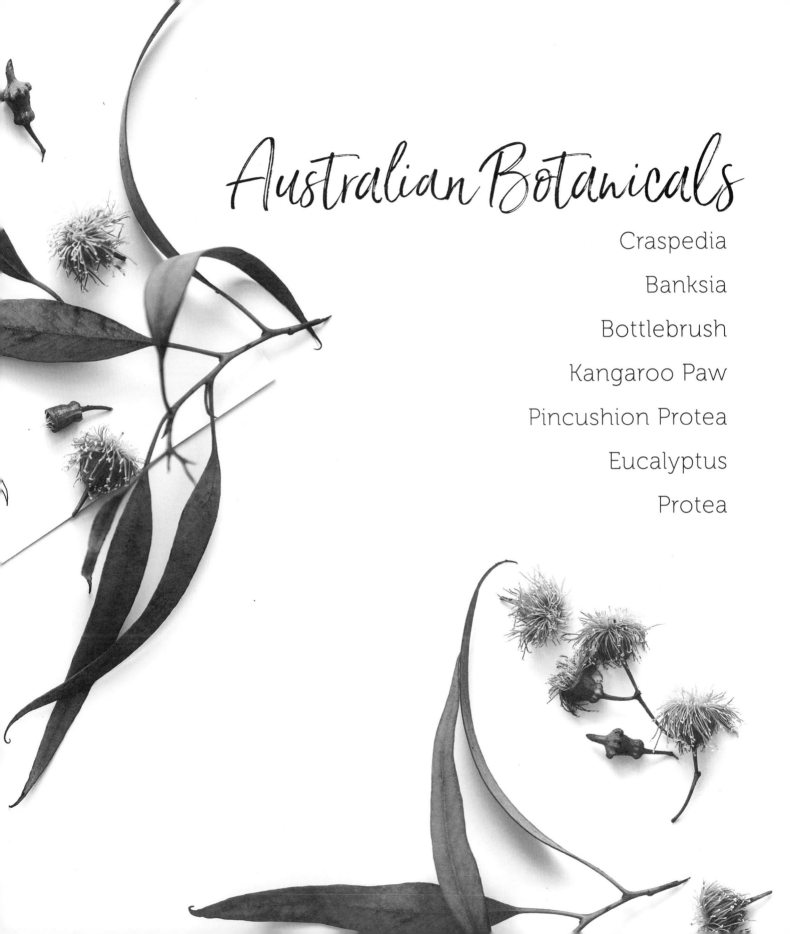

Australian Botanicals

Craspedia

Banksia

Bottlebrush

Kangaroo Paw

Pincushion Protea

Eucalyptus

Protea

Craspedia

Craspedia globosa
Enchanting
NATIVE TO AUSTRALIA AND NEW ZEALAND

Also known as billy buttons and woollyheads, craspedia are the perfect addition to a whimsical flower bouquet because of their unique spherical shape. Composed of many tiny florets, these cheerful little orbs are actually related to the daisy. Craspedia wildflowers are found in the forests of Australia and New Zealand, and they grow without any leaves.

Tip

These flowers are perfect drawn or arranged live in combination with other flowers in a bouquet, as they add visual texture and variety. Plus, they only take a few minutes to draw!

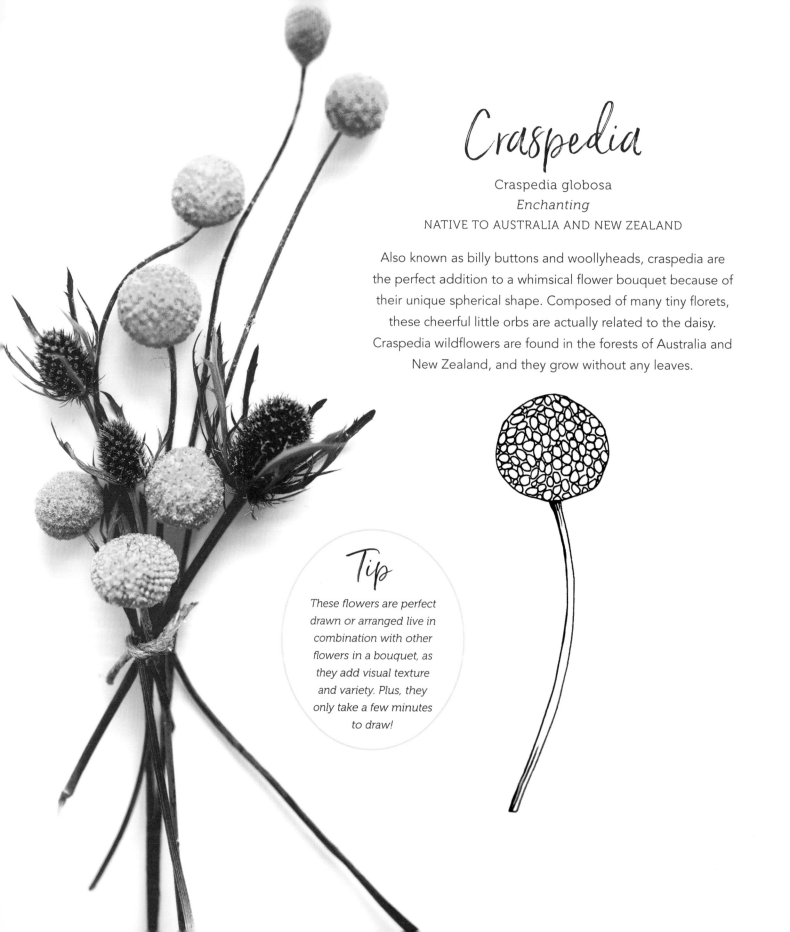

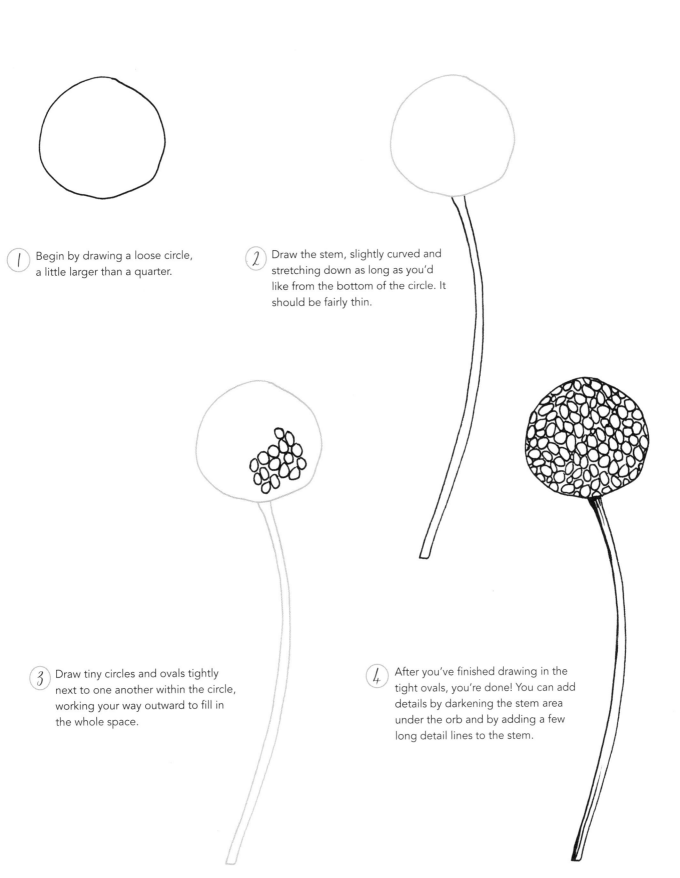

1. Begin by drawing a loose circle, a little larger than a quarter.

2. Draw the stem, slightly curved and stretching down as long as you'd like from the bottom of the circle. It should be fairly thin.

3. Draw tiny circles and ovals tightly next to one another within the circle, working your way outward to fill in the whole space.

4. After you've finished drawing in the tight ovals, you're done! You can add details by darkening the stem area under the orb and by adding a few long detail lines to the stem.

Banksia

Banksia burdettii
Wild
NATIVE TO AUSTRALIA

The banksia is an unusual Australian wildflower that is essential to the native ecosystems in the bush due to its heavy nectar production. It feeds and attracts many animals like rainbow lorikeets, honeyeaters, pygmy possums, bats, and more. This woody shrub relies on bushfires to release its seeds, and some banksia species can reach as high as 30 meters tall. The huge flower head grows upright with brightly colored spikes and has serrated leaves.

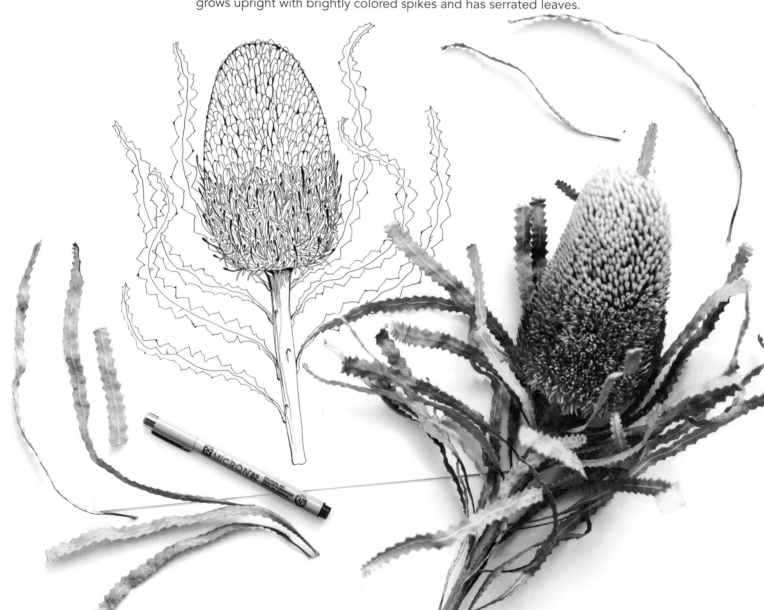

1 We'll start by drawing the outline of the flower head. Draw a large egg shape, with the bottom being a little wider and flatter.

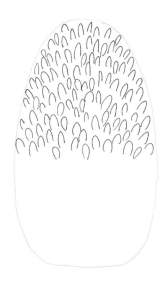

2 Next, begin to draw the many "flowers" within the egg shape. The flowers look like the tip of a cotton swab, all facing vertically. Leave the bottoms open. Start to fill out the top half of the egg shape with these.

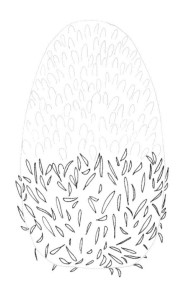

3 On the bottom half of the flower head, draw a variety of soft spikes and elongated teardrops facing in all directions like sprinkles. Begin to fill out this lower area with these, and let some overlap the edge of the egg shape.

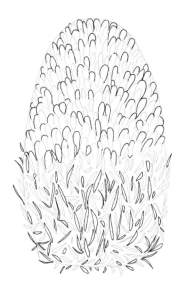

4 Now completely fill in the whole flower head with the same shapes you created in steps two and three. On the top half, the flowers should overlap behind each other to create a cohesive pattern.

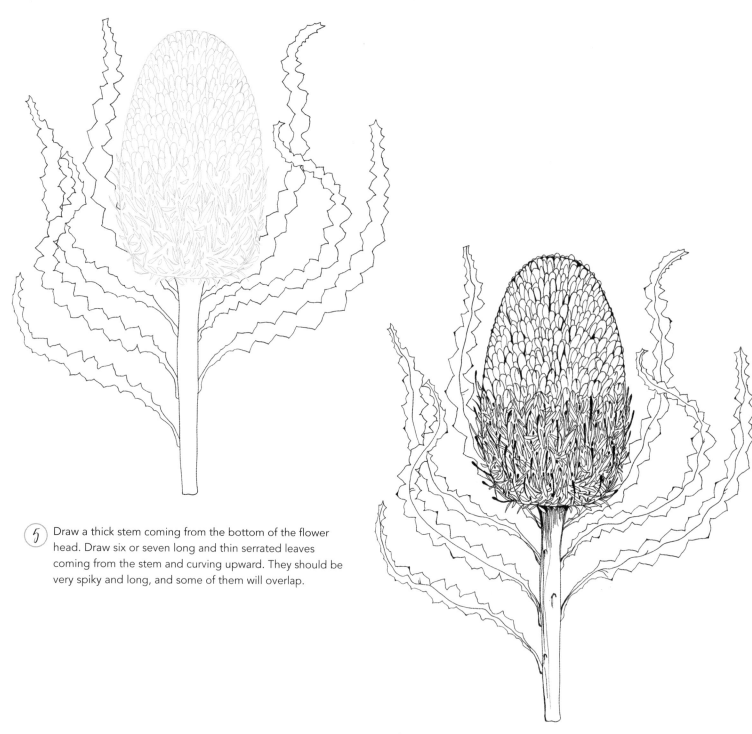

⑤ Draw a thick stem coming from the bottom of the flower head. Draw six or seven long and thin serrated leaves coming from the stem and curving upward. They should be very spiky and long, and some of them will overlap.

⑥ To complete the flower, fill in any gaps on the top half of the banksia with black. On the bottom half of the flower, add a layer of short black lines that curve upward and stop with a rounded end. These lines will go directly over the spiky shapes on the bottom of the flower. Draw a line down the middle of each of the leaves, and add a series of lines coming down from the top of the stem to make it look woody. Add little bumps on the stem by creating half-circles.

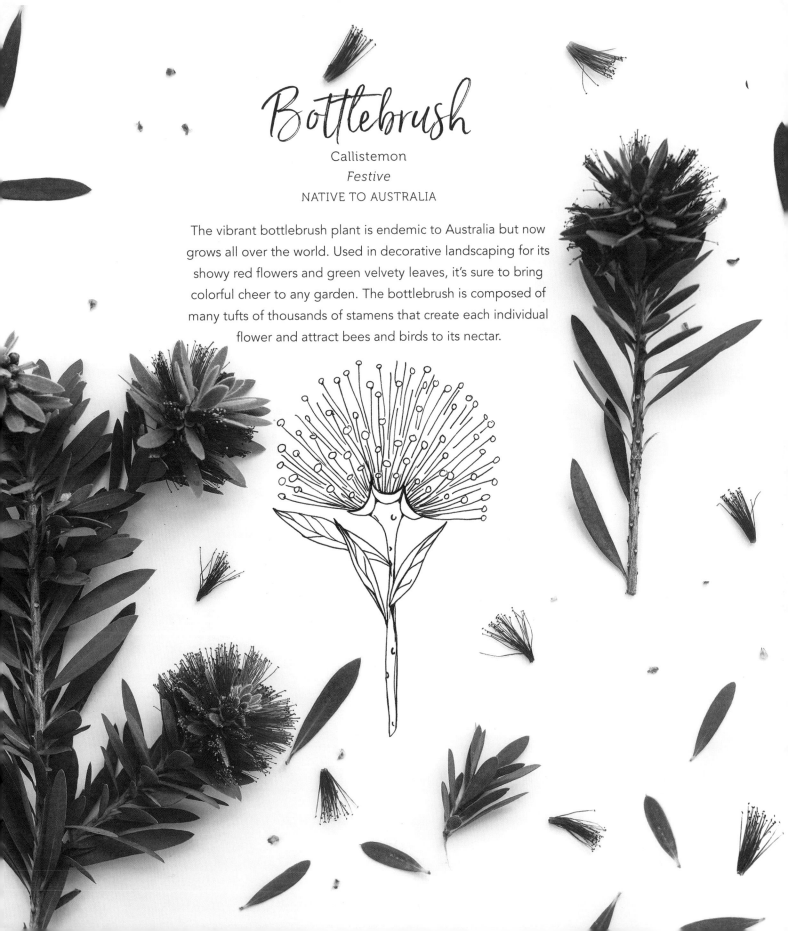

Bottlebrush

Callistemon
Festive
NATIVE TO AUSTRALIA

The vibrant bottlebrush plant is endemic to Australia but now grows all over the world. Used in decorative landscaping for its showy red flowers and green velvety leaves, it's sure to bring colorful cheer to any garden. The bottlebrush is composed of many tufts of thousands of stamens that create each individual flower and attract bees and birds to its nectar.

(1) We'll draw the bottlebrush from the side so it's easier to see the whole flower. Begin with the cones from which the bristles come out. Draw three small crescent moons touching each other, with the one in the middle facing upward and two on either side tilted away.

(2) Draw the stamens at varying lengths coming upward and outward from the crescent moon shapes. They should look like tiny lollipops, with straight lines jutting out for the filaments and circles on the top for the anthers.

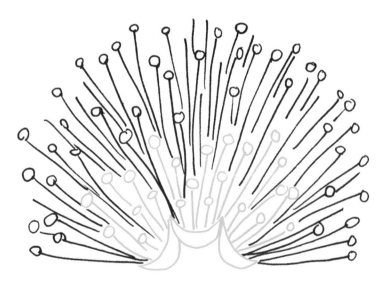

(3) Build upon the last step by creating many more layers of stamens. It will start to look like a firework on the top half. Continue drawing stamens until the top of the whole flower reaches an even half-circle.

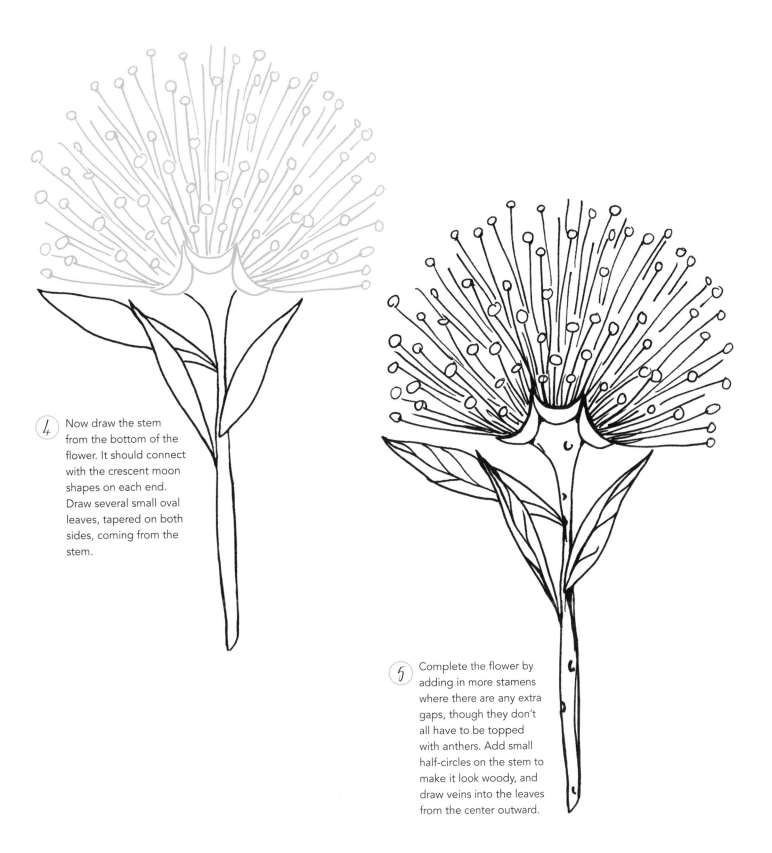

4 Now draw the stem from the bottom of the flower. It should connect with the crescent moon shapes on each end. Draw several small oval leaves, tapered on both sides, coming from the stem.

5 Complete the flower by adding in more stamens where there are any extra gaps, though they don't all have to be topped with anthers. Add small half-circles on the stem to make it look woody, and draw veins into the leaves from the center outward.

Kangaroo Paw

Anigozanthos
Enduring
NATIVE TO WESTERN AUSTRALIA

Used as the floral emblem of Western Australia, the bizarre and beautiful kangaroo paw is an Australian icon. Upon closer look, you'll realize quickly how much it resembles the paw of a kangaroo. Cute and fuzzy, these flowers come in an array of colors and can be found growing all around the Australian outback. Now cultivated around the world, they are a great addition to gardens with dry climates, as they are drought tolerant and can endure the heat of the sun.

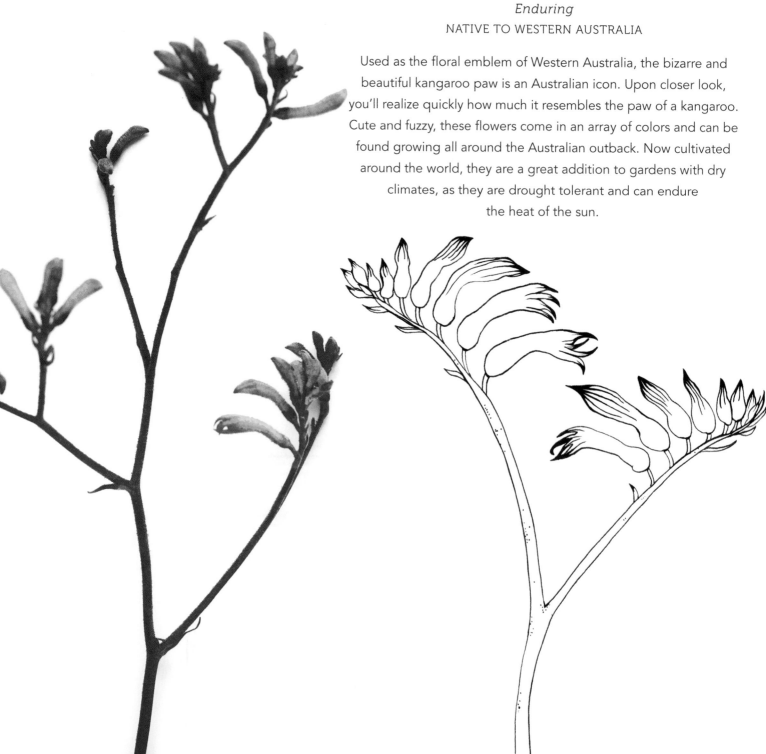

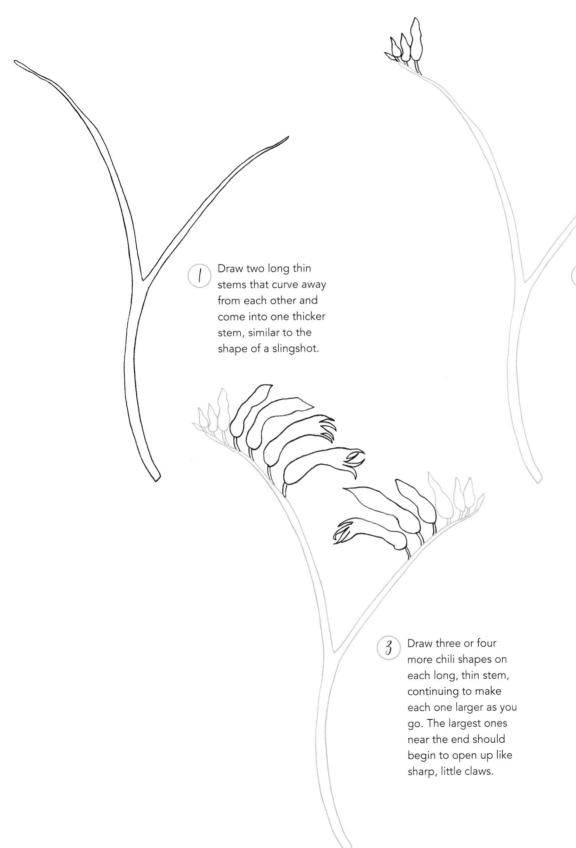

1. Draw two long thin stems that curve away from each other and come into one thicker stem, similar to the shape of a slingshot.

2. On the inside tips of the slingshot, draw four little "chili pepper" shapes with short stems facing upward. Start with a very small shape at each tip, then draw the shapes progressively larger as you go down the stem. Space them closely to one another.

3. Draw three or four more chili shapes on each long, thin stem, continuing to make each one larger as you go. The largest ones near the end should begin to open up like sharp, little claws.

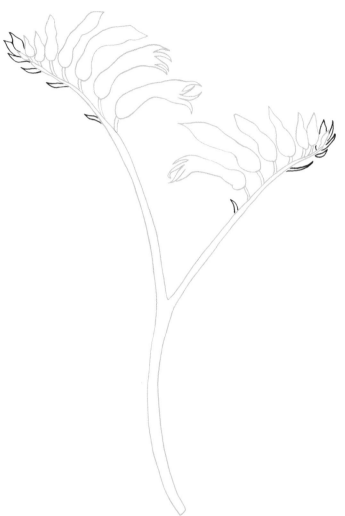

4 Add a sparse layer of very small, pointed leaves on the outsides of the branches. Then add a few extra flower buds to the tips of the branches, layered behind the buds drawn in step two.

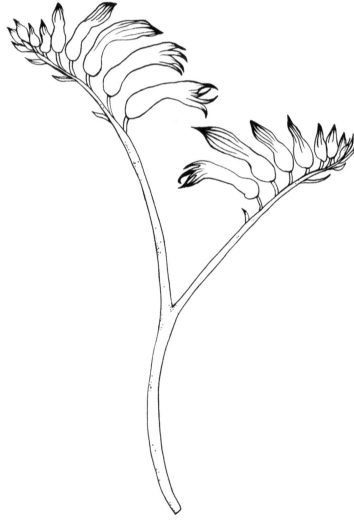

5 To complete the flower, add details by drawing a series of lines going downward from the tips of the buds. Darken the tips of the kangaroo paws for contrast, and add clusters of little dots on the branches to give it a fuzzy look.

Pincushion Protea

Leucospermum
Exotic
NATIVE TO SOUTH AFRICA AND THE SOUTHERN HEMISPHERE

The protea family comprises a group of ancient plants that come from South Africa. Australia and South Africa share similar flora because they were once connected long ago when their lands were merged in the subcontinent Gondwana. Today, the pincushion protea is heavily cultivated in Australia, as it grows well in nutrient-deficient soil. It is seen as an exotic addition to bouquets for its unique and striking floral structure.

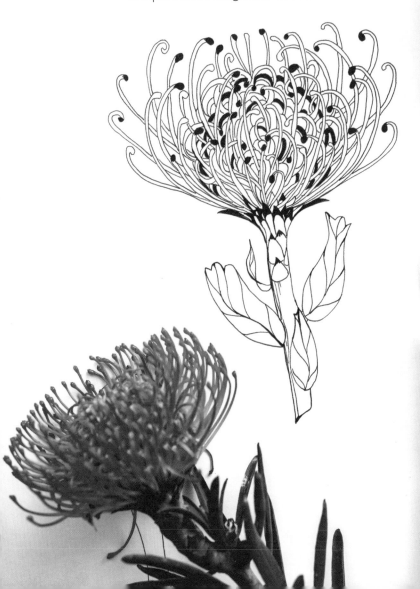

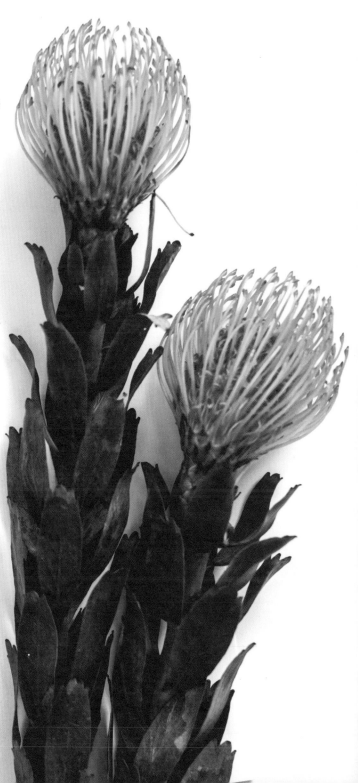

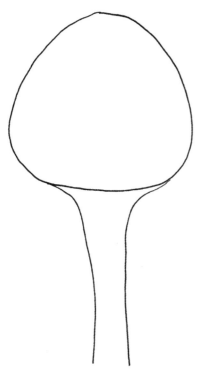

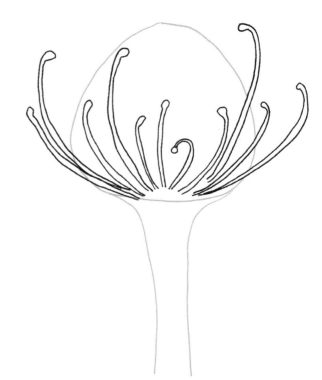

1. With a pencil, sketch a rounded orb above a thick stem. Leave the bottom portion of the stem unfinished.

2. With a pen, and using the orb shape as a guide, begin to draw the "pins" of the pincushion. These curved columns are actually the pistils of the flower. With this first layer, start at the bottom of the orb and draw the pistils curving upward and curling at the tips. Each pistil ends in a rounded point.

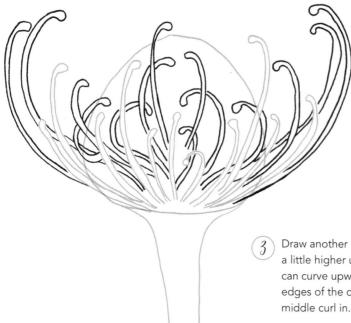

3. Draw another layer of pistils, this time a little higher up on the orb. Some can curve upward from the outer edges of the orb. Let the pistils in the middle curl in.

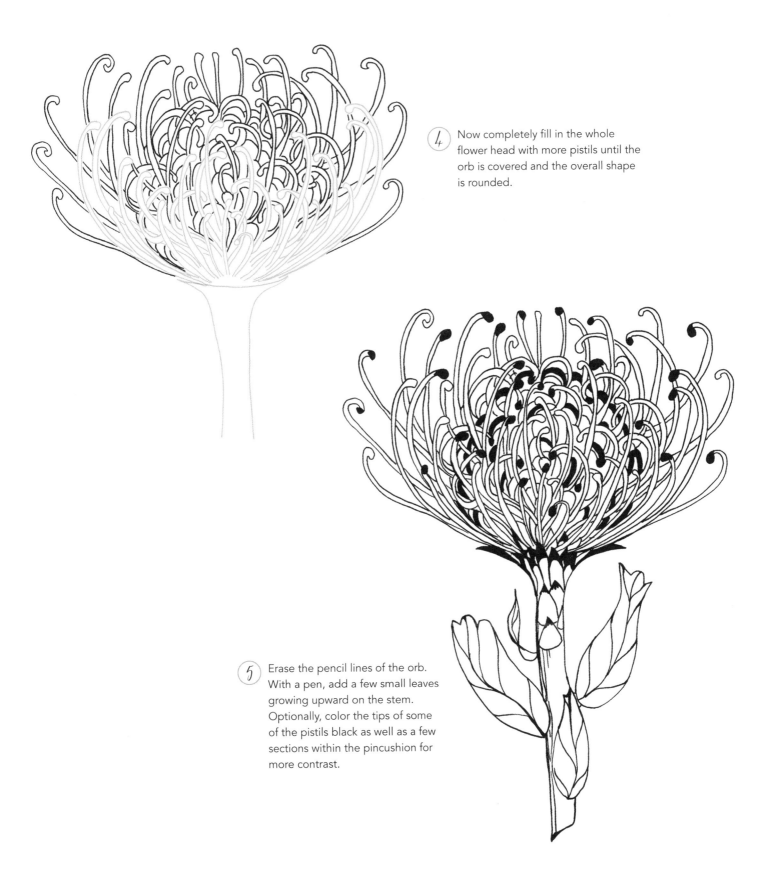

4 Now completely fill in the whole flower head with more pistils until the orb is covered and the overall shape is rounded.

5 Erase the pencil lines of the orb. With a pen, add a few small leaves growing upward on the stem. Optionally, color the tips of some of the pistils black as well as a few sections within the pincushion for more contrast.

Eucalyptus

Eucalyptus torquata
Healing
NATIVE TO AUSTRALIA

The eucalyptus tree, also known as the gum tree, is native to Australia. One species, *Eucalyptus regnans,* is the tallest flowering plant on Earth. Eucalyptus oil has well-known health benefits due to its antimicrobial qualities. It is highly effective in treating respiratory problems as well as being antibacterial, anti-inflammatory, and a stimulant.

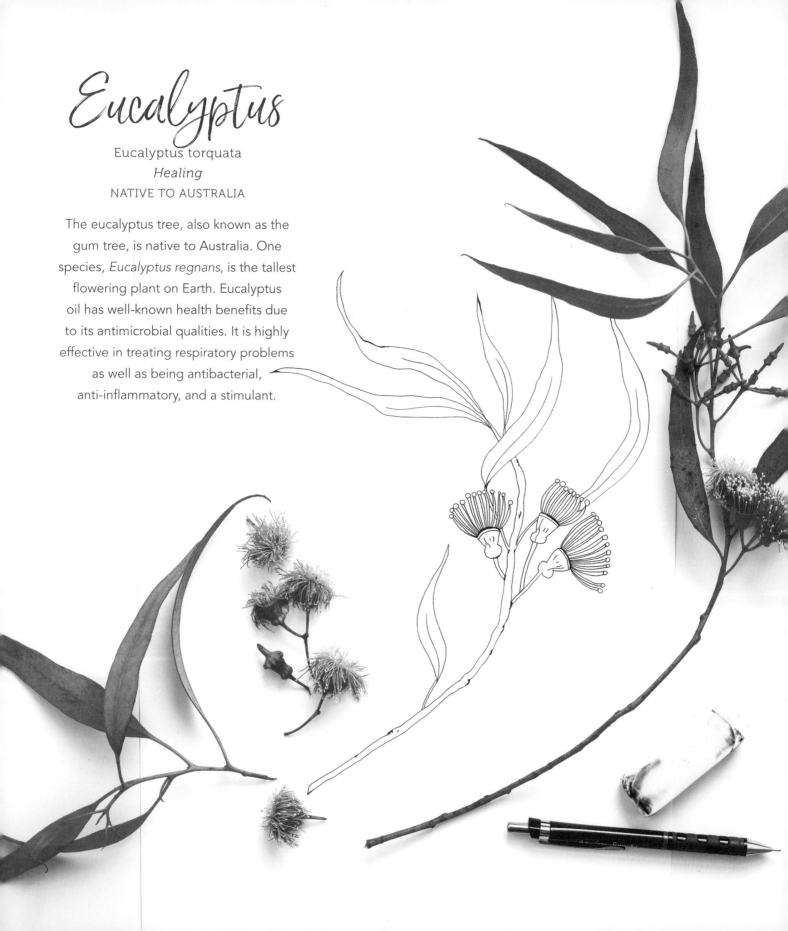

1. Draw a long, thin stick curving downward to one side, and leave the bottom end unfinished. Add a few smaller branches coming from the main stick, and leave those ends unfinished as well.

2. Choose three of the smaller branches and draw small bell shapes with rounded tops coming from the end of each one. This will be the base of each eucalyptus flower.

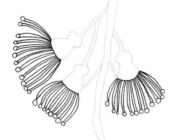

3. Now draw the stamens of each flower. Starting from the bottom end of each bell shape, draw many long, thin columns finished with small circles, like matchsticks. They should come outward like a hand spreading fingers.

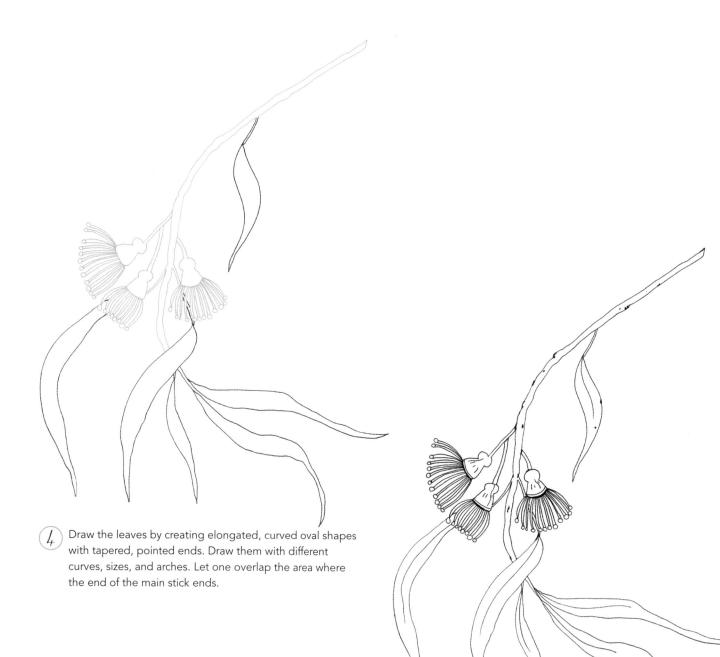

④ Draw the leaves by creating elongated, curved oval shapes with tapered, pointed ends. Draw them with different curves, sizes, and arches. Let one overlap the area where the end of the main stick ends.

⑤ Add details by drawing dots and dark patches on the leaves and bark in a few places throughout. Draw vein lines through the leaves from the base, following the flow of their shapes. Give the flower buds definition by making short tick marks in their middles, and draw an extra line along the bottom of the bell shapes.

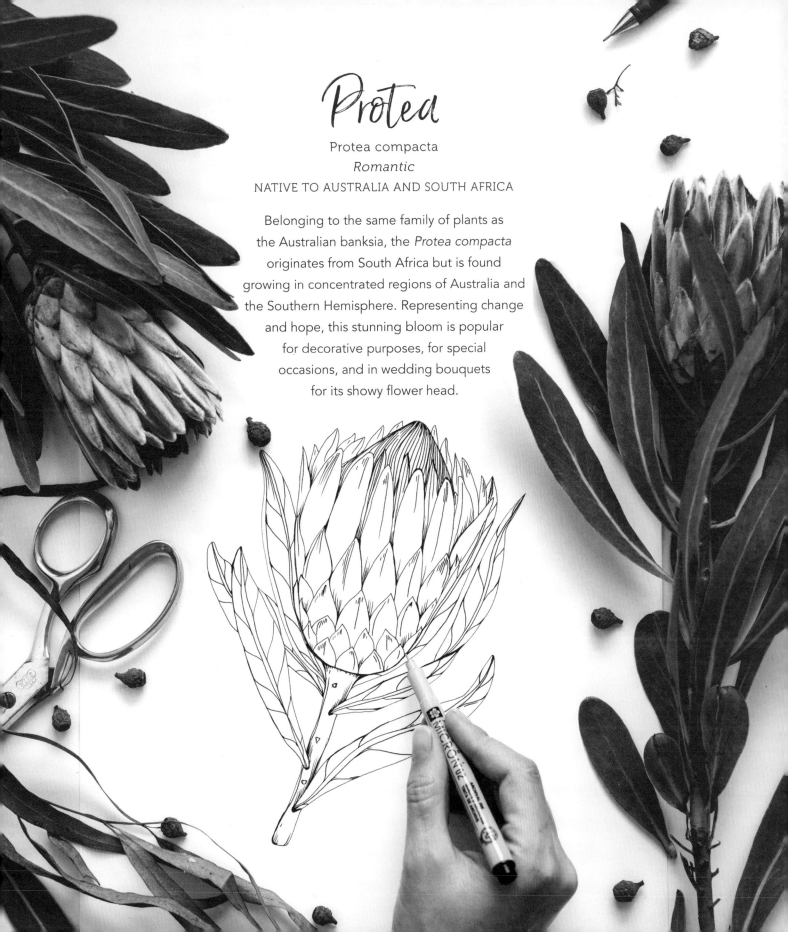

Protea

Protea compacta
Romantic
NATIVE TO AUSTRALIA AND SOUTH AFRICA

Belonging to the same family of plants as the Australian banksia, the *Protea compacta* originates from South Africa but is found growing in concentrated regions of Australia and the Southern Hemisphere. Representing change and hope, this stunning bloom is popular for decorative purposes, for special occasions, and in wedding bouquets for its showy flower head.

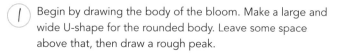

1. Begin by drawing the body of the bloom. Make a large and wide U-shape for the rounded body. Leave some space above that, then draw a rough peak.

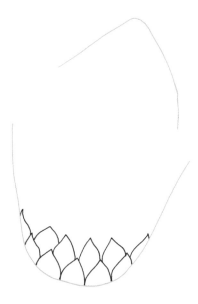

2. Inside the bottom of the U-shape, draw two layers of bracts overlapping each other in a scale-like pattern. They are soft triangle shapes pointing upward.

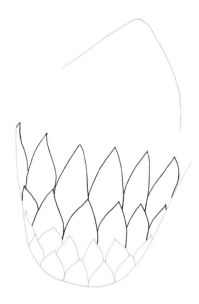

3. Draw another two layers of bracts above the last, making these a little larger and longer than the previous layers.

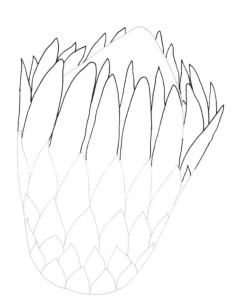

4. Add two more layers of bracts until you reach the top of the peak, making them even longer and softly rounded at the tips. Add a layer behind the peak, at the same height.

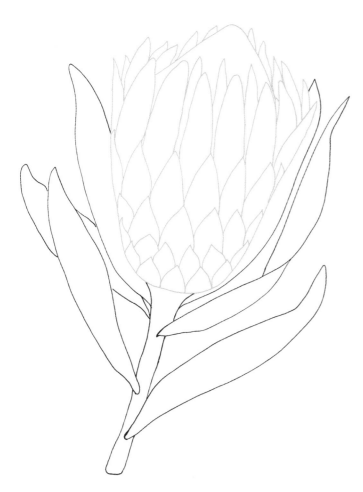

5 Draw a thick, woody stem coming from the flower head, then add several thick leaves. These will mimic the size and shape of the bracts, though they should be a little longer.

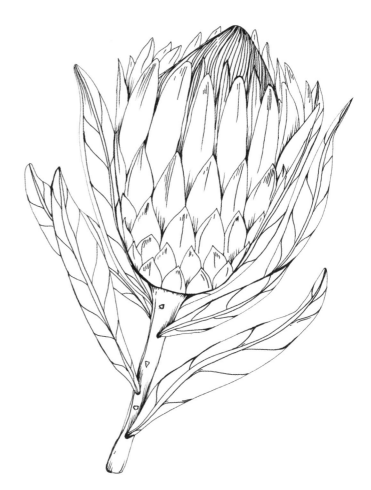

6 To complete the flower, add several vertical lines coming down from the tip of the peak. On each of the bracts, draw short lines in the middle and at the base to add texture. Darken the areas where there are gaps between the bracts for contrast. Draw veins down the middle of the leaves, with smaller veins coming outward from those. On the stem, add short lines coming up from the base of the leaves, and draw small circles to give it a woody texture.

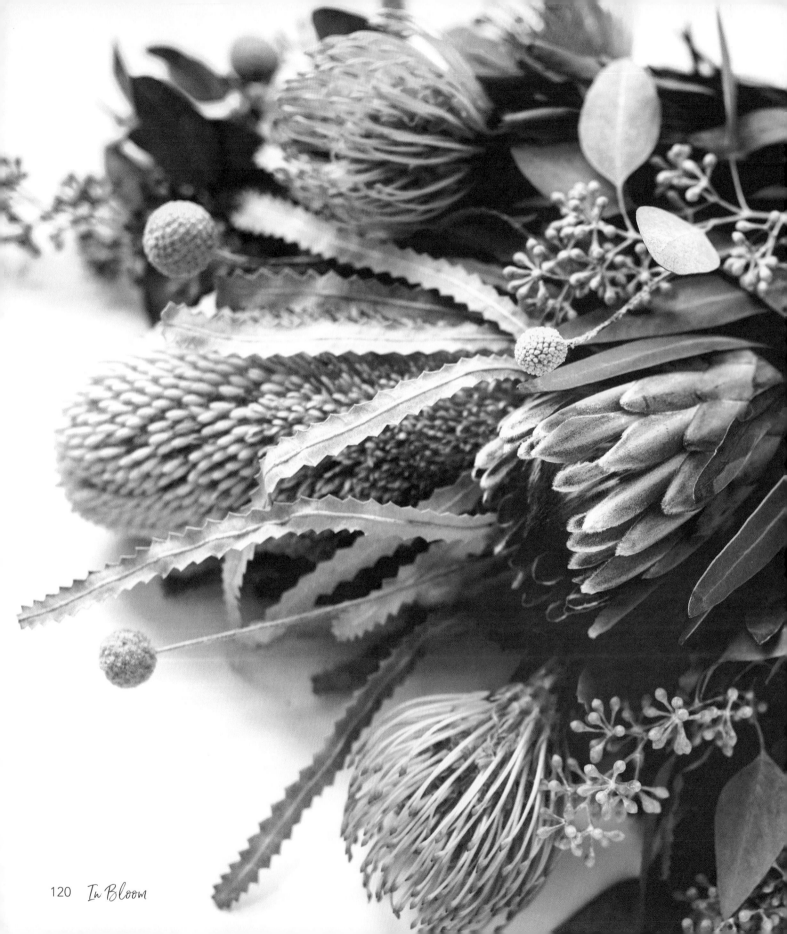

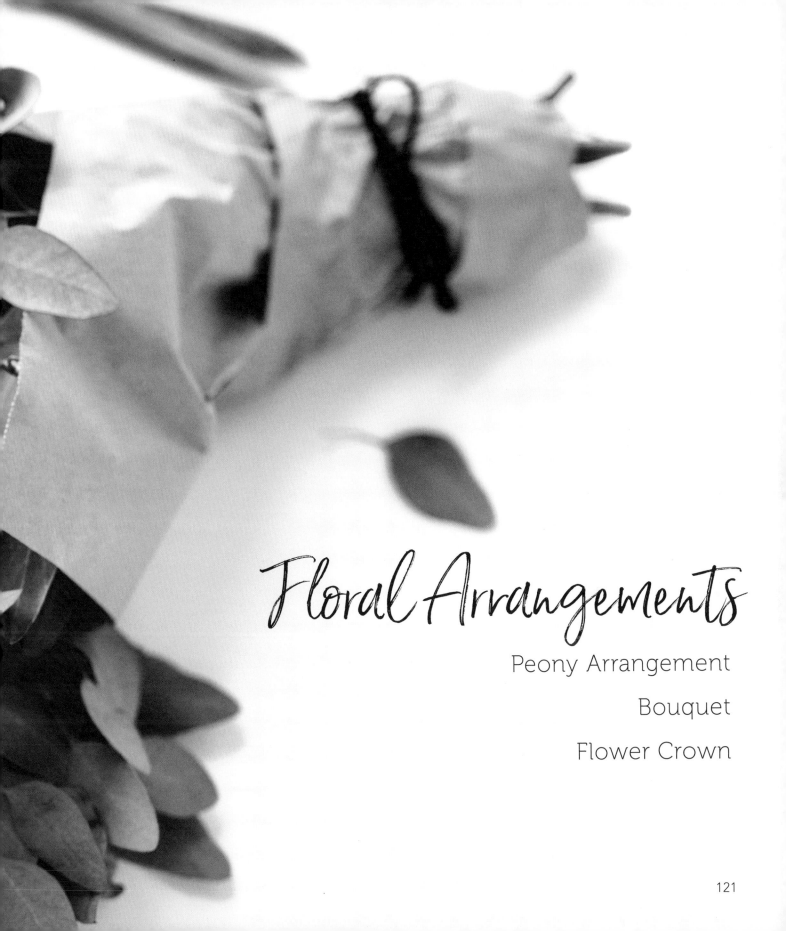

Floral Arrangements

Peony Arrangement

Bouquet

Flower Crown

Peony Arrangement

Capture the beauty of the moment. Drawing one bloom is lovely, but why not take it further and ink in a whole arrangement? If you're ready to take the next step, try drawing three flowers from different angles arranged together. In this project we'll draw three bursting peony blooms in a bunch for a beautiful arrangement that can be colored in, used as a decorative enhancement, or just left as is!

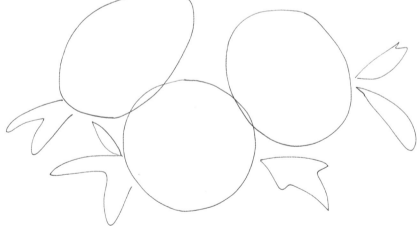

1. With a pencil, sketch three large, loose circles that slightly overlap. Draw a few quick shapes as a visual guide to represent leaves.

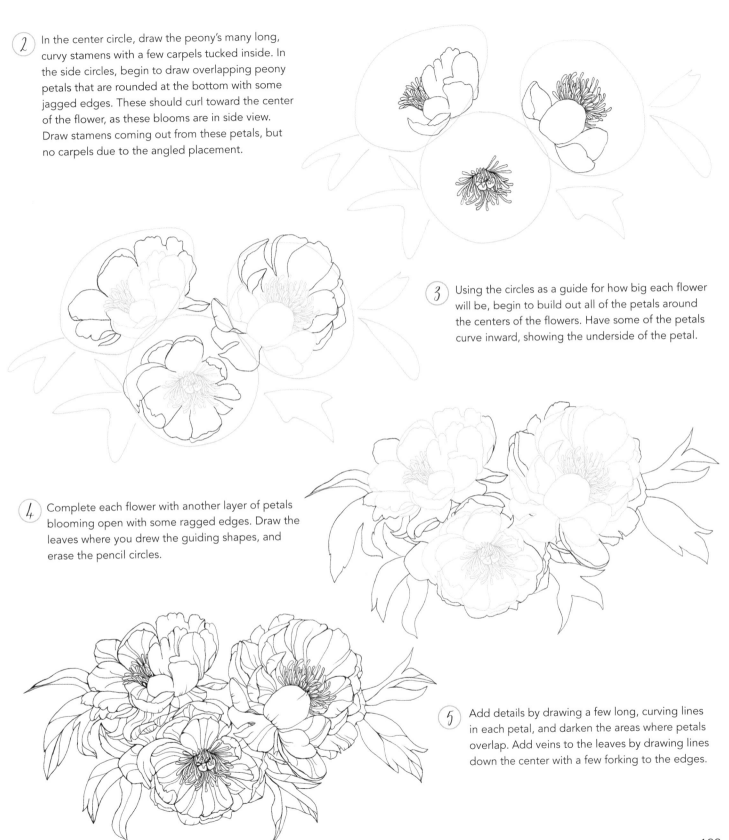

2 In the center circle, draw the peony's many long, curvy stamens with a few carpels tucked inside. In the side circles, begin to draw overlapping peony petals that are rounded at the bottom with some jagged edges. These should curl toward the center of the flower, as these blooms are in side view. Draw stamens coming out from these petals, but no carpels due to the angled placement.

3 Using the circles as a guide for how big each flower will be, begin to build out all of the petals around the centers of the flowers. Have some of the petals curve inward, showing the underside of the petal.

4 Complete each flower with another layer of petals blooming open with some ragged edges. Draw the leaves where you drew the guiding shapes, and erase the pencil circles.

5 Add details by drawing a few long, curving lines in each petal, and darken the areas where petals overlap. Add veins to the leaves by drawing lines down the center with a few forking to the edges.

Bouquet

A colorful bouquet of flowers is one of the prettiest things to behold.
If you're working with live florals, arrange them so that there is a visual
balance of larger blooms, for emphasis, surrounded by smaller blooms,
and add longer bits of foliage in spaces for interest.

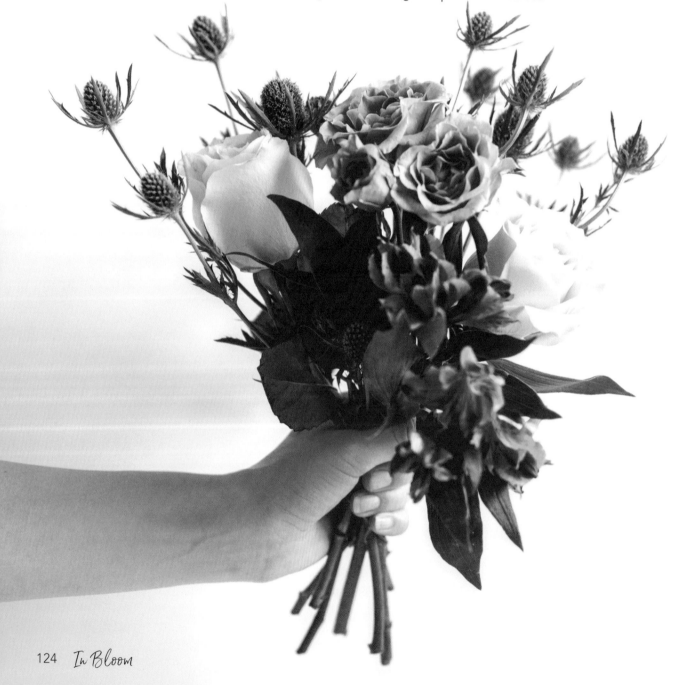

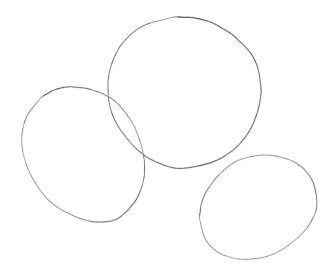

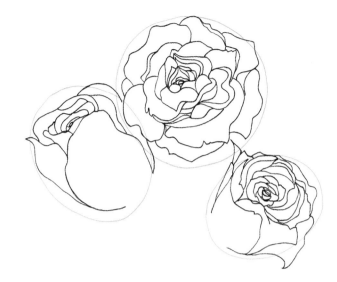

① Draw three large circular shapes with a pencil as shown, with one higher, larger one in the center and two smaller oval shapes on the sides. These shapes can overlap slightly.

② In the large center circle, use a pen to draw a rose opening toward you. Draw a rose from the side view in the oval on the left, and draw a smaller, tilted rose in the circle on the right. (Refer to p. 86 for rose steps.)

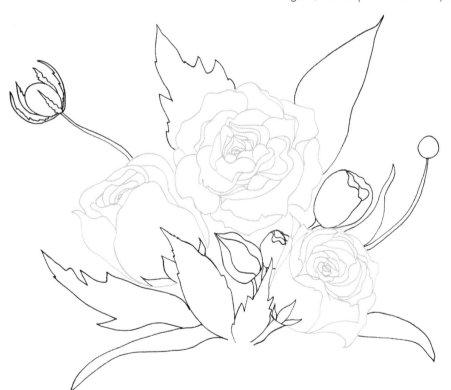

③ Erase the pencil lines, then begin to build out the bouquet with greenery and other organic elements. Add craspedia (p. 101) or sea holly (p. 89) sticking out of the bouquet, and draw various leaves tucked in behind and overlapping the roses.

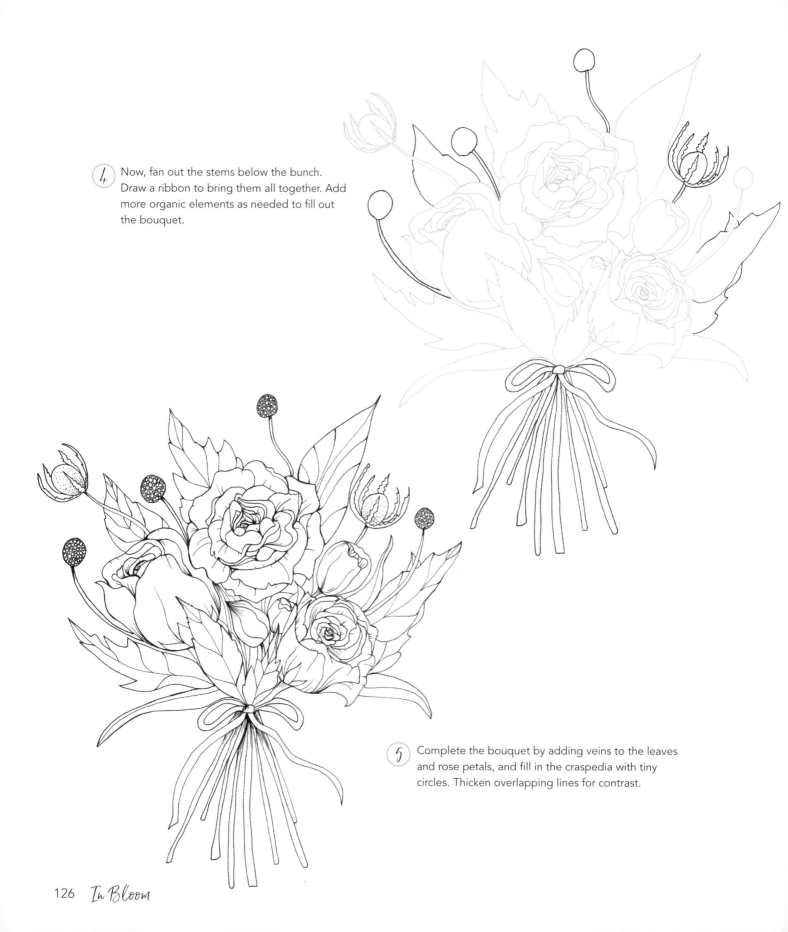

4 Now, fan out the stems below the bunch. Draw a ribbon to bring them all together. Add more organic elements as needed to fill out the bouquet.

5 Complete the bouquet by adding veins to the leaves and rose petals, and fill in the craspedia with tiny circles. Thicken overlapping lines for contrast.

Flower Crown

Let's be honest—any occasion that includes a chance to wear a crown of flowers is delightful! There are endless variations—try arranging a succulent crown, baby's breath, simple daisies, or your native local blooms. This project will show you how to arrange one using blooms from a top view, but remember you can substitute any foliage with whatever florals you like.

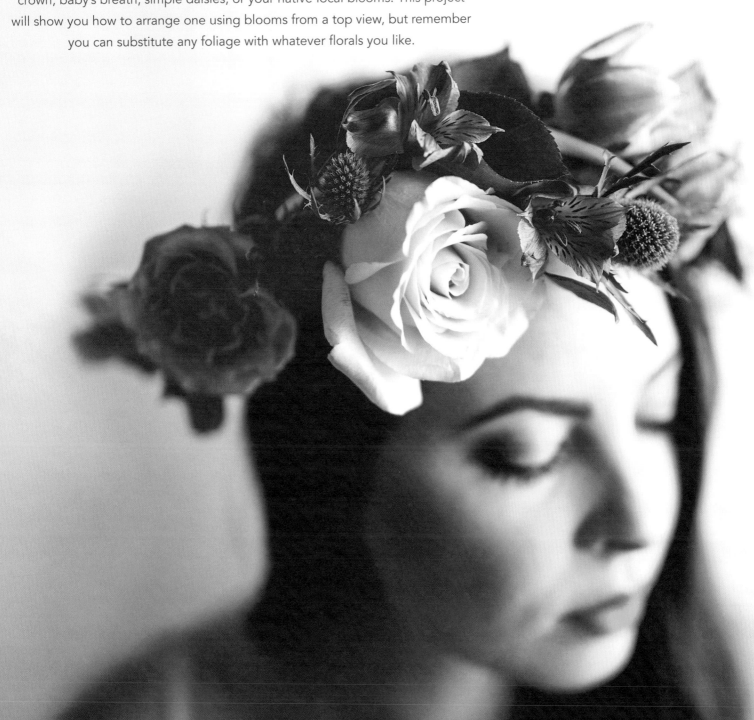

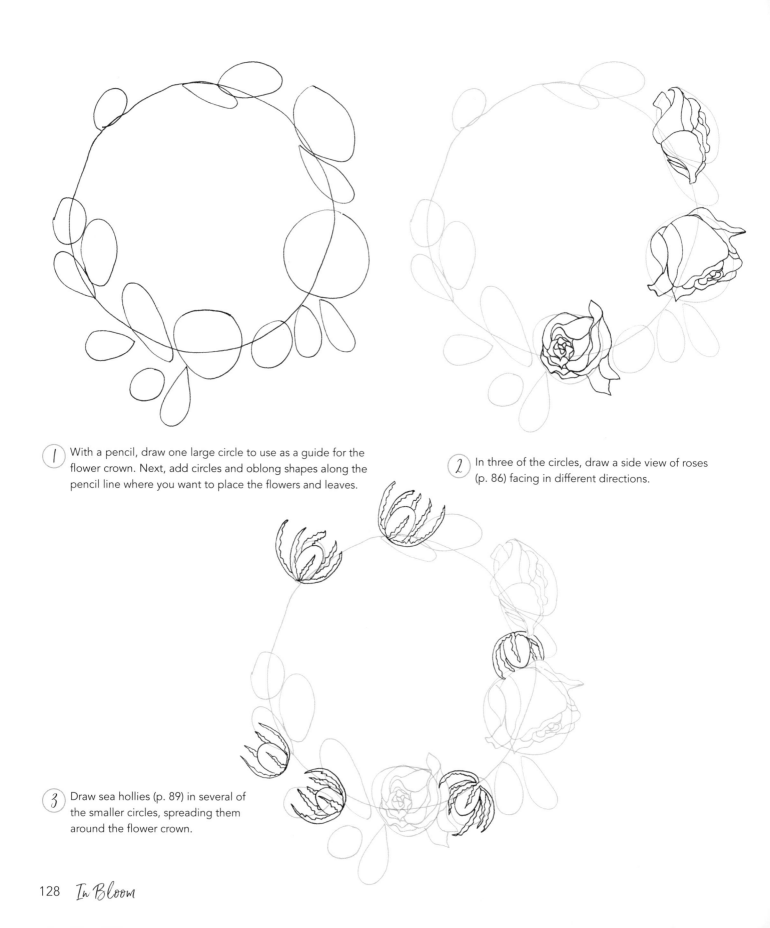

1. With a pencil, draw one large circle to use as a guide for the flower crown. Next, add circles and oblong shapes along the pencil line where you want to place the flowers and leaves.

2. In three of the circles, draw a side view of roses (p. 86) facing in different directions.

3. Draw sea hollies (p. 89) in several of the smaller circles, spreading them around the flower crown.

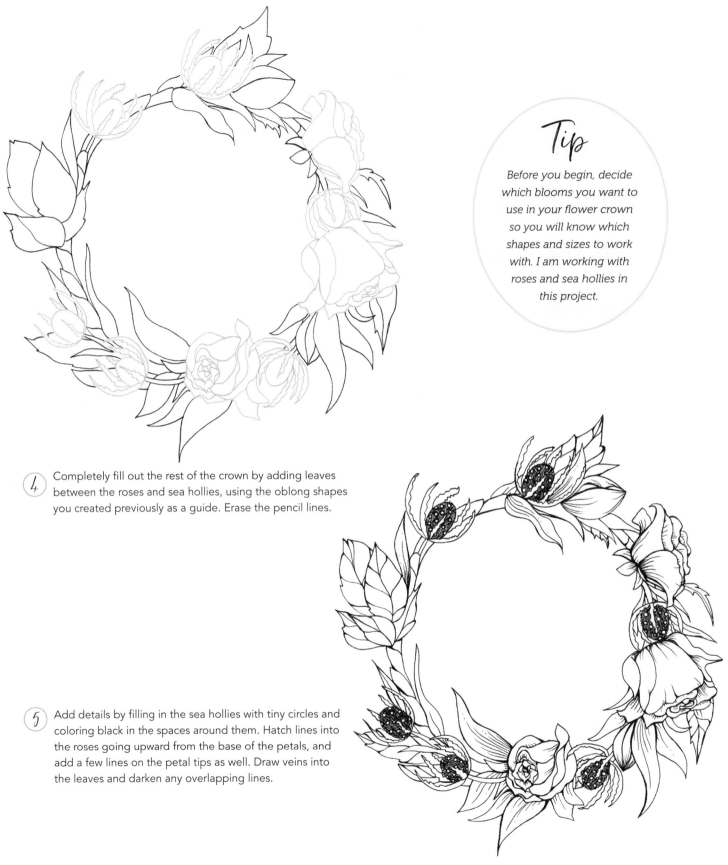

4 Completely fill out the rest of the crown by adding leaves
between the roses and sea hollies, using the oblong shapes
you created previously as a guide. Erase the pencil lines.

5 Add details by filling in the sea hollies with tiny circles and
coloring black in the spaces around them. Hatch lines into
the roses going upward from the base of the petals, and
add a few lines on the petal tips as well. Draw veins into
the leaves and darken any overlapping lines.

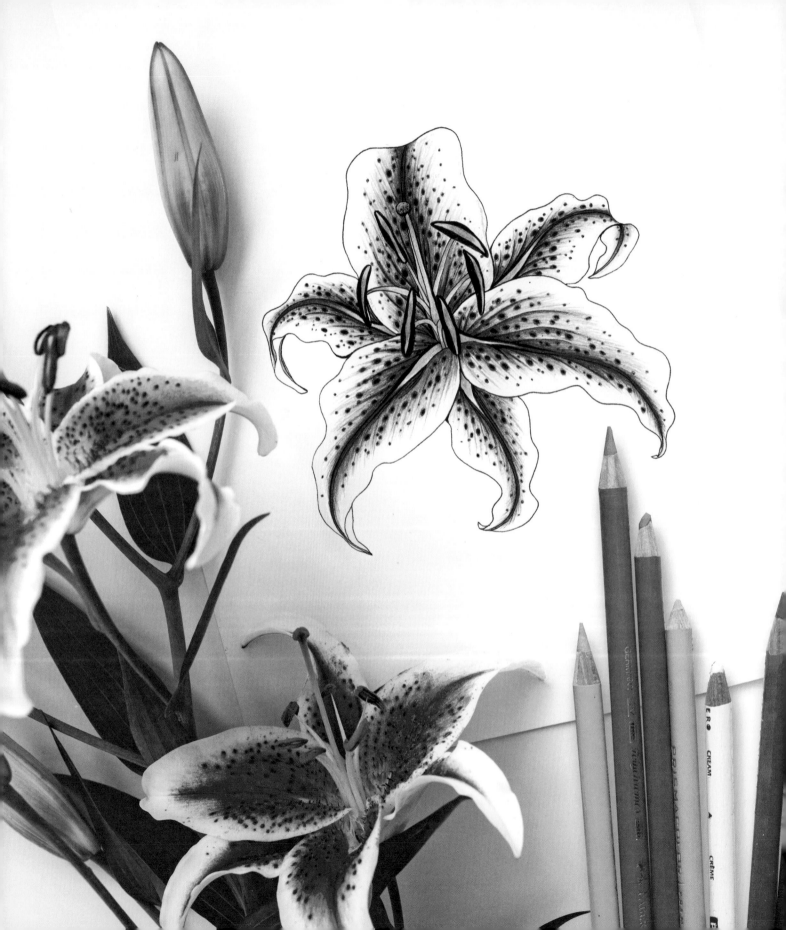

Coloring Flowers

Stargazer Lily

Peony Arrangement

Calla Lily

AFTER SO MUCH PRACTICE DRAWING FLOWERS, learning techniques for coloring them in only makes sense. In this section, I'll walk you through a few step-by-step coloring projects for flowers in this book. This is just a quick look at how to add color to brilliant blooms; it doesn't include all of the in-depth information I'd like to cover. However, I have written a book that does just that! If you're looking for the coloring bible, *Color Workshop* is entirely devoted to the art of coloring. Please look for it wherever books are sold.

The colored pencil projects in this book employ basic coloring techniques: hatching, scumbling, burnishing, and layering. If you are not familiar with these terms, here's a brief outline:

- **Hatching:** a series of closely spaced lines going in one direction
- **Scumbling:** similar to scribbling; making small circles in all directions
- **Burnishing:** using heavy pressure to press pigment into paper to get vibrant color
- **Layering:** placing several colors on top of one another consecutively

I've also included one wet-media project, because watercolor florals are so lovely. I used a very basic set of watercolors that can be obtained easily at an affordable price. For beginners and those who want to practice without investing in a professional watercolor set, I recommend Artist's Loft Fundamentals Watercolor Pan Set, 36 Colors. For the colored pencil projects, I use Prismacolor Premier pencils. Beginners might consider using Crayola, but I always recommend high-pigmented pencils for better results. A dusting brush is also really helpful to remove any pencil debris without smearing it across the page, though an ordinary makeup blush brush is a fine substitute. Last, a decent pencil sharpener is essential—I use only a metal handheld one for the sharpest point.

Let's get coloring!

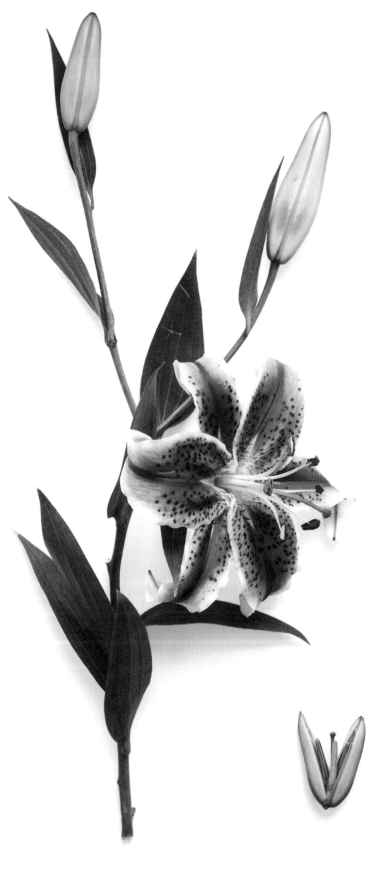

Coloring a Stargazer Lily

Coloring a stargazer lily is a great project for beginning colorists who want to practice blending and hatching. This flower is so striking with its pink and white petals and bright green stamens. It's also a fantastic reference flower for learning, because it is inexpensive and easy to find at any time of the year, its large flower head allows you to see details easily, and the blooms last long enough for you to draw and color from life.

TOOLS

Prismacolor Premier
Colored Pencils:
Neon Yellow (PC1035)
True Green (PC910)
Grass Green (PC909)
Neon Pink (PC1038)
Magenta (PC930)
Dahlia Purple (PC1009)
Sand (PC940)
White (PC938)
Chartreuse (PC989)
Orange (PC918)

Pencil sharpener

Dusting brush

NOTE: See p. 11 for a diagram of the stargazer lily's anatomy.

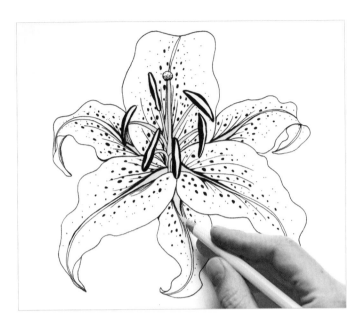

①　With Neon Yellow, use medium pressure to color the filaments, the style, and the beginning of the large middle vein on each of the petals.

②　Now add a layer of True Green at the top of the filaments and style, blending it into the Neon Yellow. Add True Green into the base of the middle petal veins, fading it into the Neon Yellow layer.

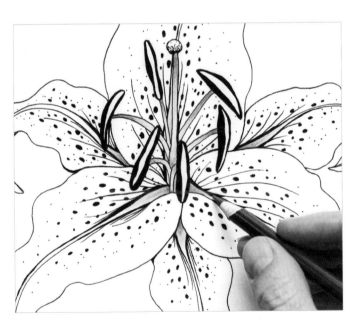

③　With medium pressure, use Grass Green to deepen the color in the areas where you laid down True Green, fading it softly into the previous layer.

④　With Neon Pink, using light pressure, draw long lines coming outward from the center vein of a petal. Use hatching to create a series of many lines like this, all going outward from the center vein toward the edges of the petal on each side until you reach the petal's tip. Color the inside of the middle vein, blending it into True Green.

5. Repeat the last step with Magenta by layering it over the Neon Pink to add depth to the color. Use gentle to medium pressure, and make sure your pencil tip is sharp for the best results. Outline the tiny black dots.

6. Repeat step 4, but this time use Dahlia Purple and more pressure to begin building vibrancy.

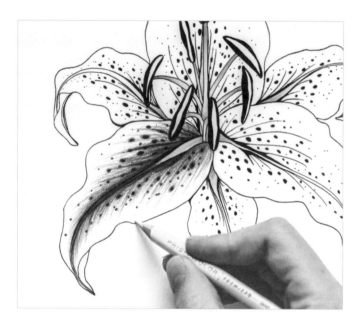

7. Using Sand, color the inside edges of the petal lightly. Stay close to the inside edge.

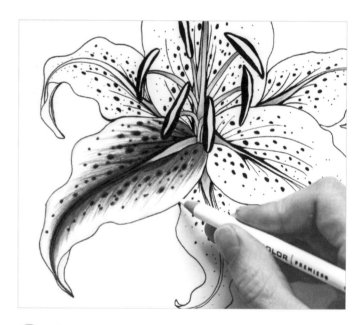

8. After you are satisfied with your blending and color, use White to burnish the entire petal.

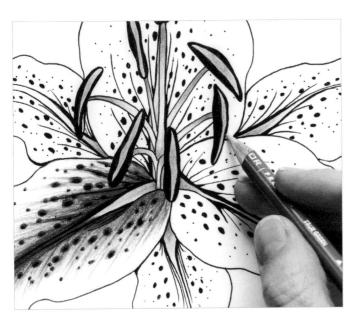

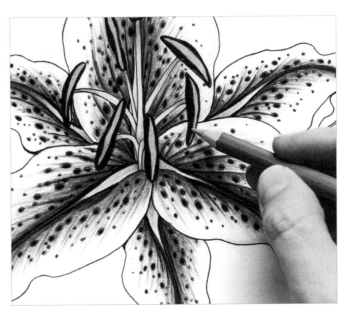

⑨ Use Chartreuse and True Green to color in the centers of the anthers. Start with True Green in the center and fade it into Chartreuse on both sides.

⑩ Lastly, add Orange to the ends of the anthers, then color in the rest of the petals following steps 4 through 8.

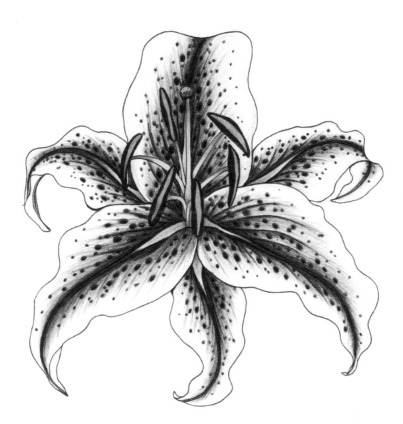

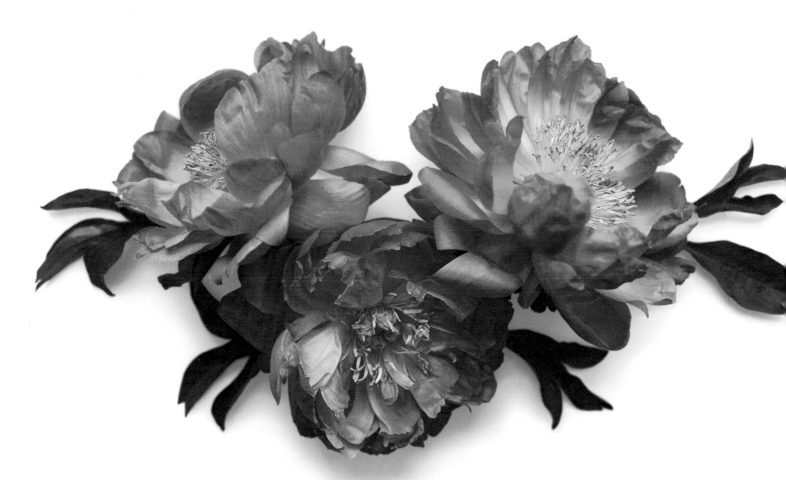

Coloring a Peony Arrangement

It's hard not to be drawn to coloring a brilliant peony bloom, let alone three together! This particular peony hybrid is called Coral Charm, so in this lesson we'll focus on blending warm peachy shades for the petals.

TOOLS

Prismacolor Premier Colored Pencils:

Light Peach (PC927)

Pink (PC929)

Carmine Red (PC926)

Process Red (PC994)

Spanish Orange (PC1003)

Tuscan Red (PC937)

White (PC938)

Grass Green (PC909)

90% Cool Grey (PC1067)

Cream (PC914)

Pencil sharpener

Dusting brush

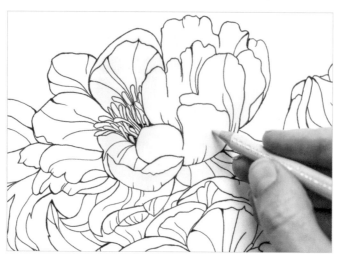

1 With Light Peach, add a soft base layer to several petals, coloring them in completely. Use very gentle pressure so that the color is hardly seen.

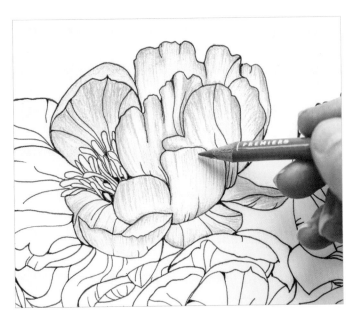

② Now begin hatching each petal with Pink. Hatch downward from the tips of each petal with long lines, moving toward the middle. Then hatch upward from the base of each petal. Curve the lines so that they go in the direction of the petal's shape. Leave some space between the lines here and there so that veins are created.

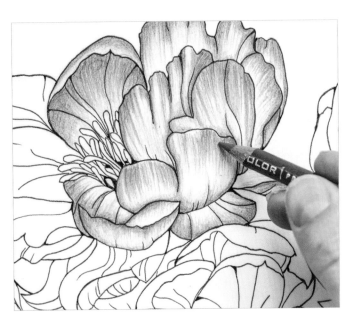

③ Going over the same lines you just created, deepen the color using Carmine Red. Begin to add more pressure with the pencil on the tips and inner edges of the petals and areas where the petals overlap.

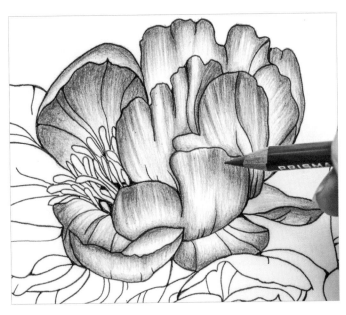

④ Now use Process Red to make the color more vibrant and pink-toned. Repeat step 3 with this color.

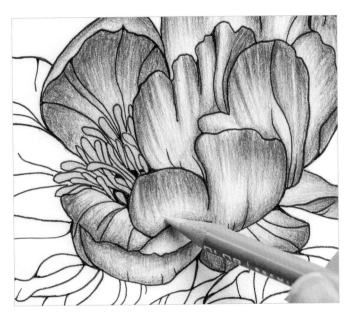

⑤ Use Spanish Orange to color in the stamens of the flower completely. Then softly hatch the color into the petals as another layer, to make the color warmer. Leave a few areas untouched to keep it bright.

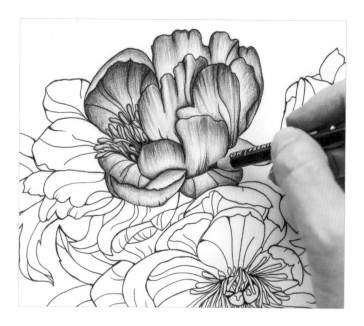

6 Add a last layer of color using Tuscan Red, pressing harder with the pencil on the edges of each petal and going over the same lines you previously put down. Blend Tuscan Red into the other layers by hatching. Softly outline the stamens to create shadow.

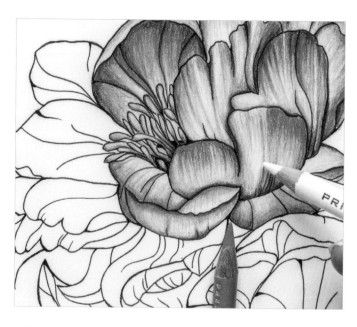

7 Once you are satisfied with your layering, burnish the entirety of each petal with White and Pink. Use White in the light areas, and Pink in the darker areas.

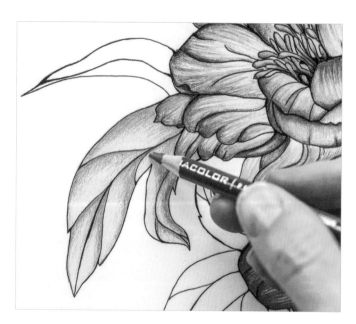

8 Now with Grass Green, use scumbling to color in the sections of the leaves. Use light pressure and gradually fade one side of each section to the white of the paper as shown.

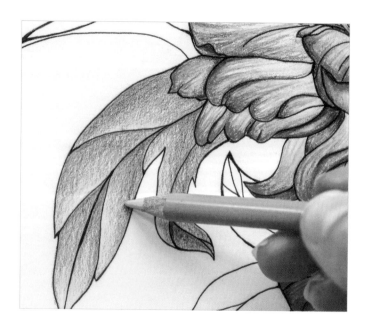

9 Using Spanish Orange, add a soft layer over Grass Green on the leaves, keeping the light end of each section uncolored.

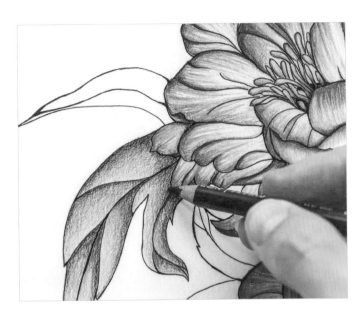

10) Add shadows to the leaves and darken the color with 90% Cool Grey. Layer this over the darkest ends of each section, keeping it in close proximity to the edges and blending it softly.

11) Use Cream to burnish the leaf sections once you are happy with your blending.

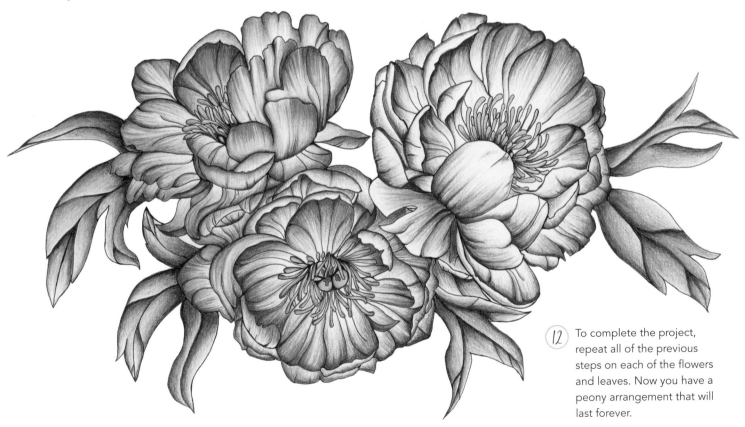

12) To complete the project, repeat all of the previous steps on each of the flowers and leaves. Now you have a peony arrangement that will last forever.

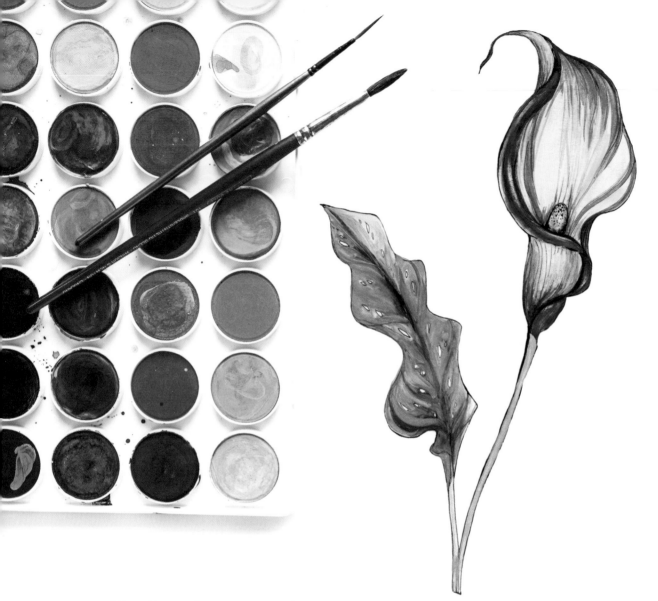

Coloring a Calla Lily with Watercolors

TOOLS

Artist's Loft Fundamentals Watercolor Pan Set, 36 Colors

Round watercolor brushes
Sizes 2, 6, 8

Water pot

Paper towel for blotting

All flowers look lovely painted with watercolors, calla lilies included. In this project, I'm using smooth Bristol paper, the same paper I use for drawing, because it is thick and can withstand some water. I use it when I am combining ink and watercolors because it's great for clean ink lines. However, I recommend using proper watercolor paper for better absorbency if you are not adding ink.

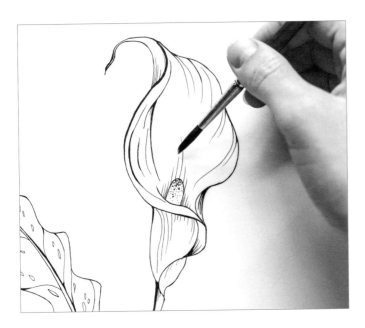

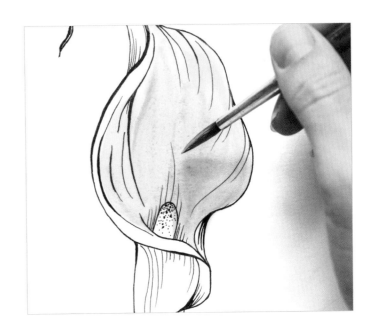

1. Using a size 8 round brush, wet the tip with clean water and brush it onto the inside of the calla lily, avoiding the carpel. This will prepare your paper for paint and give your paint a place to go in the next step.

2. While the paper is still wet, use yellow paint and a size 6 brush to paint into the same area where you added the water. Completely fill in the inner petal.

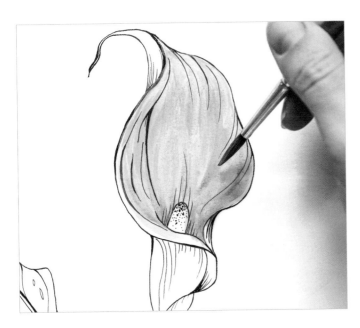

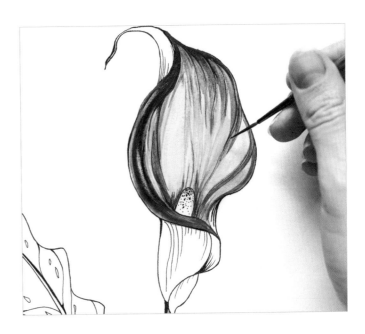

3. With light orange and the same brush size, add a soft layer of color by painting into the top inside area of the petal, brushing it down toward the carpel.

4. Now with the size 2 brush, paint strokes of maroon downward from the top of the petal. Paint the edges of the inner petal with maroon, leaving some strokes showing over the orange and yellow layer.

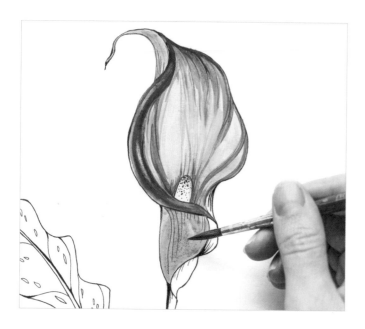

⑤ With a size 6 brush, blend brown and green together. Paint the blended color into the bottom of the lily and the top underside of the petal.

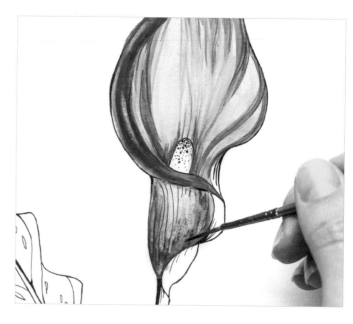

⑥ While the brown-green paint is still wet, add maroon to the bottom of the lily where you added the brown-green, blending it upward.

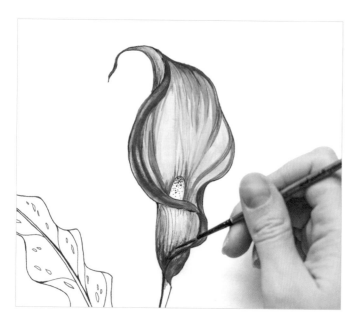

⑦ Paint maroon into the top twisted petal so that it blends with the green, and complete the flower by painting in the folds as well.

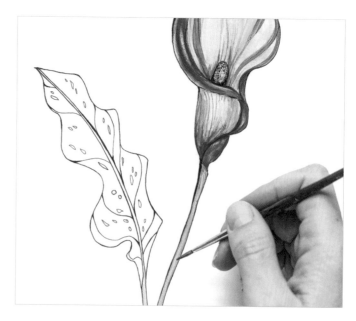

⑧ With a size 2 brush, paint the pistil yellow. While the paint is still wet, brush a tiny bit of brown at the bottom to create a light shadow and blend it upward. Clean your brush, then paint the stem a medium green.

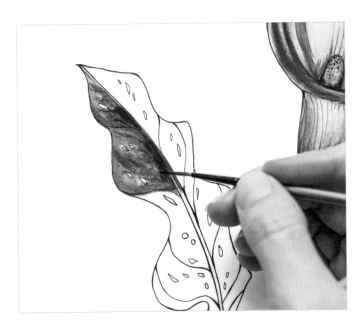

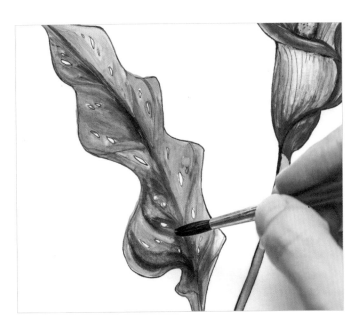

9 With that same green, begin to paint the leaves one section at a time. Blend dark green into the medium green along the inside vein.

10 Repeat the last step to finish painting the entire leaf, using a size 6 brush for the larger areas.

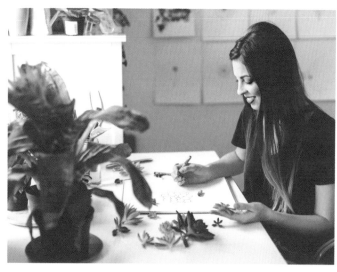

About the Author

Hi, I'm Rachel Reinert, and I live in a tiny cottage in San Diego, California, with my husband and plants. On most days, you can find me working on many projects in my home studio. My background is in art education, and I currently have an online coloring course called Coloring Masters available on my website. Creating is my thing, and I love what I do. Whether it's drawing, painting, coloring, crafting, teaching, gardening, photographing, filming, or styling, I don't let a day go by without being creative!

I also love being in nature and observing its wonders. The natural world is my number one inspiration in my artwork. So far, I have authored three books inspired by my love for plants and my travels around the world. Be sure to check out my coloring books *Botanical Wonderland* and *Desert Wonderland*, as well as *Color Workshop*, an in-depth guide to all things coloring, in stores and on Amazon.

Please visit me at instagram.com/rachelreinertstudio or on my website at **rachelreinert.com** to see more of my work.

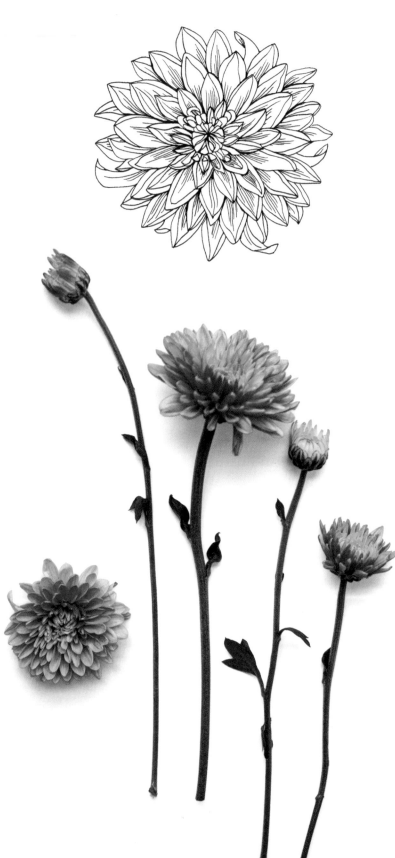